P9-DVU-709

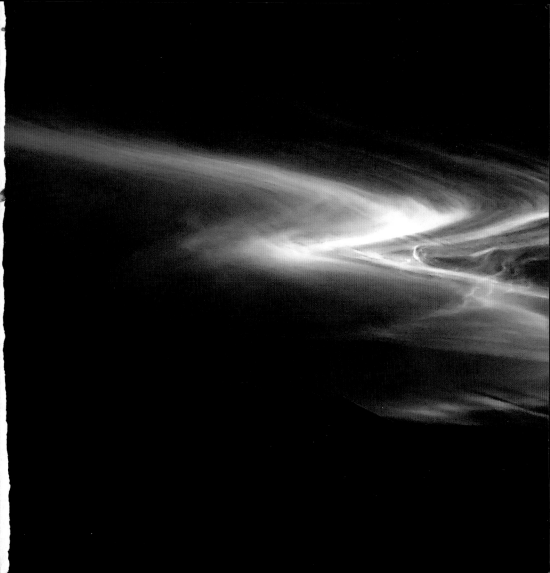

Kaleidoscope

Sky

Tim Herd

Abrams, New York

Contents

The heavens declare the glory of God;
the skies proclaim the work of his hands.

Psalm 19:1

To Carol,
my loving wife and best friend,
who adds even more beauty to my life

Introduction

Diffuse pastel-tinted rings encircle a full moon and fade, as a red to orange to yellow- blue dawn overspreads the sky. A change of wind clears the morning mists, and a warm light heats the landscape until trees invert, signs vanish, houses stretch, and "water" shimmers on the highway. High overhead, new circlets target the sun and sprout assorted appendages, while luminous smudges and specks mock its brilliance. Elsewhere, a brightly packed cumulus grows tall then wide then dark. Lightning rips through wet, green air as crimson sparks tear toward space. The cleansing storm wipes the sky aquamarine and trails a shiny array of concentric colored arcs. A sinking and flattening Sun paints a fiery western skyscape and winks out with a hasty emerald flash. Tinctures stratify on the horizon as diminishing light smears orange to lilac to purple. The light's afterglow yields to dancing strands of sky-high garnet and jade glistening in a cobalt setting.

Earth's unique atmospheric blend of nitrogen, oxygen, water, and other gases not only hosts and sustains life as we know it, but also filters a constant shower of radiation, some of which is visible energy, from a nearby ordinary star—the Sun.

Immersed in such energized air, our eyes reveal an ever-shifting and versicolored pageant of arriving light—spectral light that slathers in hues both subtle and vibrant; redirected light that sprays designs in midair; lustrous light that glints and tints and glows; dazzling light that flickers vividly and shimmers resplendently; even warped light that tricks eyes, distorts views, and hides solid objects.

Of such dynamic and primal light-borne beauty, we—who alone among the planet's inhabitants can observe and cherish it—are the sole beneficiaries. Within these pages are but a few captured moments when the skylight briefly flowered, flashed, and flaunted its celestial artistry. Yet every day the everlasting and ever-enchanting light show beckons for deeper understanding and appreciation.

Although grasping complex optical physics can be daunting, herein is an attempt to illuminate and illustrate the elaborate phenomena by presenting the basic light wave mechanics and interpreting what the various displays mean, while admiring their pure aesthetics. I invite you to join me—to observe, study, and enjoy the visual feats and temporal treasures of our changing kaleidoscope sky.

—Tim Herd

Chapter 1

Light Gets the Bends
Showtime Optics for Sky Observers

Our yellow star couches in a mantle of clouds and bathes it red over the Pyrenees of Spain. A minute portion of the Sun's total output is responsible for the incredible variety of colors, streaks, patterns, and optical effects as it penetrates the Earth's atmosphere in just a few millionths of a second.

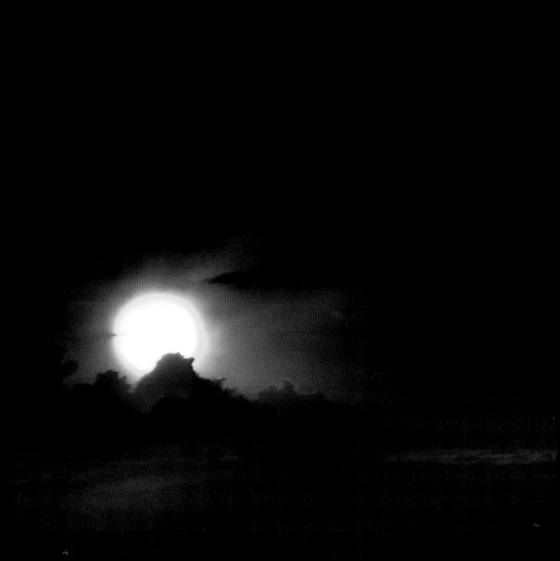

As light streaks through the atmosphere and interacts with its gases, water, and dust, it produces a continual stream of luminous reactions and countless fascinating displays of optical imagery—from the momentary and barely noticeable pale and subtle air-smudges, to the hours-long, strikingly vivid, and brightly hued attention grabbers. The source of all this radiance is, of course, the Sun, even though the Moon, shining by the Sun's reflected light, contributes its own share.

To more adequately understand light's behavior and to better seek out its effects as it negotiates the atmosphere, we begin with a few basic concepts—in what we may call a Sky Observer's Primer—and an introduction to using the practical features of each chapter to help locate, observe, predict, interpret, and investigate our select specimens of spirited study.

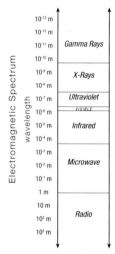

SOLAR RADIATION

Radiation is a classy word for the Sun's energy, which is transmitted in the form of electromagnetic waves. Its full production spectrum includes gamma rays, X-rays, ultraviolet, visible light, infrared, microwaves, and radio waves.

Visualizing radiation as waves may seem like a simple enough concept, but it was one that was unsettled for some two hundred years as experimenters noticed that sometimes this energy acted like waves, and other times it acted like a stream of particles. Through the pioneering work of physicists Thomas Young and Albert Einstein, we now have confirmation that electromagnetic radiation is actually both waves *and* particles; and when it acts like the latter, it is called photons.

The Earth's atmosphere is a real-life force field that prevents most of these waves from penetrating to the ground and harming living things. The shortest—gamma rays, X-rays, and the bulk of ultraviolet rays—act as photons when they strike, imparting their energies to atmospheric gases at very high altitudes. In lower levels of the atmosphere, many of the longer infrared waves are also absorbed by carbon dioxide and water vapor.

Visible Light color	Wavelength range (nm)
violet	390–455
dark blue	455–485
light blue	485–505
green	505–550
yellow-green	550–575
yellow	575–585
orange	585–620
red	620–760

VISIBLE LIGHT WAVES Like all other types of waves, light waves are measured as the distance from the peak of one crest to the peak of the following crest. The nanometer (nm) is the common unit of length used to express light wavelengths. One nanometer is one thousand millionths (10^{-9}) of a meter.

Of the full range of solar radiation, only two distinct portions pass easily through the atmosphere. One is the wide range of long radio waves; the other, a tiny fraction we can see with our eyes: visible light.

EARTH'S ATMOSPHERE

With its unique proportion and mixture of gases, water, dust, and airborne particles, the atmosphere makes life possible, weather interesting, and its optical properties fascinating. The atmosphere is abundant enough to be held by gravity and allow us to breathe with ease; viscous enough to transport moisture and swirl about on the surface; and conductive enough to absorb heat and transmit electricity. Our atmosphere is thin enough to be transparent to visible light, yet thick enough to filter life-harming ultraviolet radiation, bending and splitting that which enters into its colored components.

The atmosphere is pulled toward the center of the Earth by gravity. The pressure of the gases, however, resists such a pull and pushes outward toward space. The result is a slender sphere of air surrounding the globe, densest at the surface, tapering off to where individual molecules of gas do not even meet one another. Fifty percent of its mass is below three-and-a-half miles above the surface; 90 percent of it is within about ten miles; and 99.9 percent of it is below twenty-nine miles. Yet even at a height of 350 miles, air exists, although its density there is about one-trillionth of that at sea level. Beyond that, atmospheric gases give way to the magnetic fields and radiation belts of outer space.

As visible light streams through the inhomogenous atmosphere, encountering air molecules in varying densities, dust of all kinds and sizes, and water in all its phases and forms, the light may be absorbed as heat, never to be seen again; or it may be bent, split, attenuated, concentrated, deflected, or otherwise diverted along its entire pathway to our eyes. Four different processes contribute to these outcomes, alone or in combination: *scattering, diffraction, refraction, and reflection*. The first three also separate light into its component wavelengths in a neat feat called dispersion. Whenever they get their cumulative act together with the ever-diverse, ever-changing weather, the resultant light show can be astonishing.

1. SCATTERING

In the vacuum of space, where nothing interferes with the solar radiation, the surroundings are black. At about sixteen miles from the Earth, the radiation's encounter with tiny particles of dust and gas molecules begins to diffuse a

SCATTERING BEHAVIOR

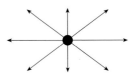

Air molecules scatter light of shorter wavelengths more efficiently than longer wavelengths, and in a symmetrical pattern.

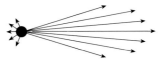

Tiny water droplets scatter light more strongly forward than in other directions, and without any preference to wavelengths.

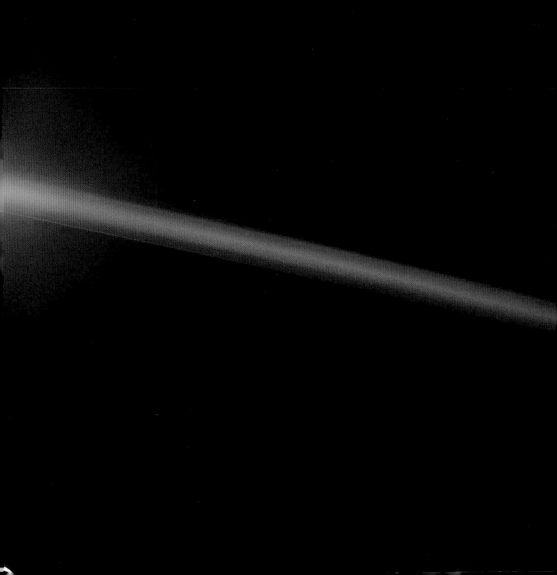

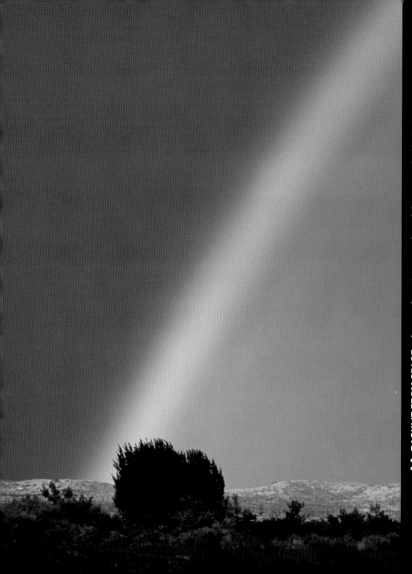

BACKLIT FROM SPACE As seen by astronauts aboard the space shuttle *Endeavour* in February 2000 at a height of 140 miles, the Earth's thin peel of an atmosphere stratifies into spectrum colors as the Sun sets below the Earth's limb. The densest part, containing the air we breathe, is in the red band below the level of the tropopause.

Not even all the colors of the rainbow are as numerous as the shades of visible light. As the wavelengths of the colors vary, so does the angle at which they bend through water, ice, or even layers of air at differing temperatures. The bright, broad bands of the familiar rainbow display are color separated by falling raindrops—here emblazoning the remnant of a storm near Socorro, New Mexico, on August 24, 2005.

portion of the energy in all directions. These particles, which may be thought of as very tiny reflectors, scatter the radiation in all directions; the amount of light and the directions in which it is scattered depends on the size of the particles.

Air molecules, which are much smaller than the wavelengths of light (about 1/1000 the size), scatter light in a symmetrical pattern. As much light is scattered straight ahead (0°) as is sent straight back toward the Sun (180°). The least amount of light is scattered at 90° to the direction of travel. This interaction is called Rayleigh scattering, named after the English physicist Lord Rayleigh, who was first able to calculate the intensities of light scattered in all directions by clean air. He also found that air scatters approximately ten times as much blue light as red light. This explains the overwhelmingly blue appearance of the clear sky overhead, as well as the yellow to orange to red tints of skylight at sunrise and sunset, when light travels through a comparatively longer cross section of the atmosphere and most of the blue light has been completely scattered away.

Because light waves from the Sun oscillate in all directions, scattering in any particular direction (other than 0° and 180°) "filters out" those waves vibrating in all other directions and produces polarized light, whose waves propagate in only one direction. Light scattered at 90° (the plane of maximum polarization) results in the minimum brightness in the sky.

As the size of the scattering particles increases, so does the intensity of the light scattered in the forward direction. Mist and fog droplets, which are comparable in size to the wavelengths of light, scatter light more strongly forward and backward, and with more or less equal intensity according to wavelength, resulting in the whiteness of their appearances.

2. DIFFRACTION

Scattering is caused by particles smaller than the wavelengths of visible light. Similar to scattering, diffraction also changes the direction and distribution of light, but it occurs when the diameter of the particles is approximately the same size or greater than the wavelength of light. At this ratio, light's wavelength—and its behavior as a wave—determines its ultimate distribution. If the crests of two waves moving in different directions reach a point at the same time, their effects add together and reinforce each other in a condition known as constructive interference. If the crest of one wave reaches a point at the same time as the trough of another wave, they cancel each other out, in a condition known as destructive interference.

3. REFRACTION

As light waves pass from one medium to another of a different density, both their speed and direction change; this effect is called refraction. Light may refract through a single medium, as when it passes through varying densities of air layers, or through two or more substances, as when it passes from air into water or ice, which usually results in dispersion. Refraction is the commonly observed effect when a stick thrust into a pond appears bent and shorter in the water.

DIFFRACTION BEHAVIOR

When waves encounter an obstruction, new circular waves are generated about the obstruction, much like the waves of a boat's wake passing a pier post. When light strikes a cloud droplet, which is about fifty times the wavelengths of visible light, the new circular waves originating on both sides of the droplet combine with the original straight waves, causing light to travel out at an angle to the original direction. (For clarity, just a portion of the circular waves is shown here.) Wave crests combine in constructive interference along the dashed lines to produce bands of maximum light intensity; between them, destructive interference results in darker areas.

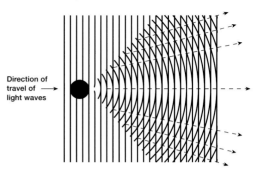

Direction of travel of light waves →

REFRACTION BEHAVIOR

The degree of refraction is measured as an angle between the bent ray and an imaginary line perpendicular to the boundary between the different densities, called the normal.

Passing from denser to less dense refracts light away from the normal (cooler air to warmer air).

Passing from less dense to more dense refracts light toward the normal (air to water or ice).

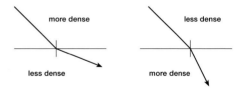

more dense

less dense

less dense

more dense

REFLECTION BEHAVIOR

In regular reflection, the angle of incidence (a) is always equal to the angle of reflection (b).

In diffuse reflection, light is reflected in many different directions without respect to the angle of incidence.

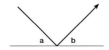

a b

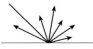

BISHOP'S RING The Bishop's Ring is produced when sunlight diffracts through a fine dust cloud—especially one caused by a volcanic eruption—forming a broad, whitish ring about the Sun, with a slight bluish tinge on the inside and a reddish brown tinge on the outside. The radius of the ring's inner edge is generally 22°–28°, and its ring width another 10°; exact dimensions are determined by the particle size of the dust. The effect is named after Rev. S. Bishop of Honolulu, who first described it after the eruption of Krakatau in 1883. This red-brown specimen appeared the afternoon of May 12, 1992, over Juva, Finland, eleven months after the catastrophic eruption of Mount Pinatubo in the Philippines.

→ **POLLEN CORONAS** Because of its uniform size, a fine mist of tree pollen can produce exceptionally vivid diffraction coronas, like these three through pine pollen near Juva, Finland. When phenomena centered on the Sun are photographed, a nearby object is commonly used to block a portion of the brightest light to avoid glare and overexposure. See Chapter 3 for more on water-droplet coronas.

When light passes through thin layers of air mixing near the surface with greatly different temperatures (and therefore densities), a fluttering effect of rapid variations in apparent position, brightness, or color is produced as the light is repeatedly refracted in the turbulence. Here, the wavy outlines of an energy plant about fifteen miles away in Lelystad, the Netherlands—as well as an inferior mirage of the rising Sun and portion of the plant's structures—shimmer on the horizon.

A good sky photographer watches the sky, prepares for the weather, and is always ready with equipment. He or she understands the phenomena, practices effective techniques, and respects others and the environment. This well-crafted image positions the strongest point of visual interest off-center, while the stark silhouette contrasts with a clear sunset's spectrum, creating an attractive and strong composition. Setting: sunset; the seacoast of Pisa, Italy; February 2006. Weather: clear and dry, low east wind, 41° F.

The amount of bending depends on the densities of the substances and the wavelengths of the light involved: the greater the difference in densities and the shorter the wavelengths, the greater the refraction. The shorter wavelengths of violet and blue light are slowed more and consequently bend more than the longer wavelengths of red and orange light.

4. REFLECTION

For reflection to occur, at least a portion of the light that strikes an object or surface is turned back. When the surface is smooth compared to the wavelength of light, as it is with a mirror—and the surfaces of water droplets and ice crystals—regular, or specular, reflection occurs. The angle of reflection equals the angle at which the light first struck the surface, called the angle of incidence. When the reflecting surface has large irregularities compared to the wavelength of light, diffuse reflection occurs, and the reflected light is sent out in many directions with no simple relationship to the angle of incidence. Diffuse reflectors include ordinary white paper, clouds, and almost all terrestrial surfaces, except for perfectly calm water.

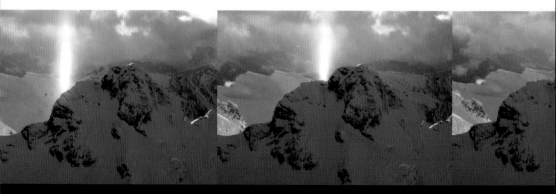

SUBSUN When light reflects off the top surfaces of horizontally oriented ice crystal plates, the Sun is brilliantly reflected in the subsun. This image can only be viewed from an airplane or high mountain, since it forms as far below the horizon as the Sun is above it. This series of images, taken at one-second intervals late in the afternoon of February 24, 2006, shows the apparent movement of the subsun as the aircraft flies from left to right past the face of the north peak of Three Fingers Mountain in Washington's Central Cascades.

LOCATING SKY FEATURES

The sky is like a gigantic living canvas on which each day's palette of light paints an ever-evolving panorama of colored streaks, displays, and featured portraits. As these transients parade with the Sun over our heads, they may appear virtually anywhere in the palatial sky dome. Locating them at any particular moment depends on their individual causes and relationships to the direction of incoming sunlight, and is specifically addressed in each of the following chapters under this heading.

However, knowing your way around the celestial sphere is helpful in both identifying the feature as well as its likely locale, given the Sun's position and track.

Many of the various halos, bows, and arcs are described and identified by their angular sizes. The unit of angle measurement is the degree, defined as 1/360 of a circle's circumference. As this applies to optical phenomena in the sky, we note the resultant angles' light is bent from its original pathway as it scatters, diffracts, refracts, and reflects—not the overall width of the display. In other words, the light that creates a 22° halo is deflected 22° away from the Sun, but from our view measures 44° wide from edge to edge.

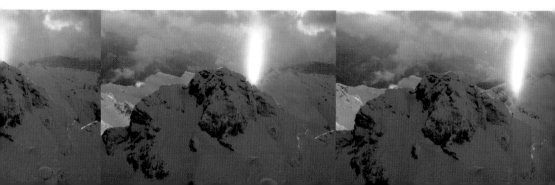

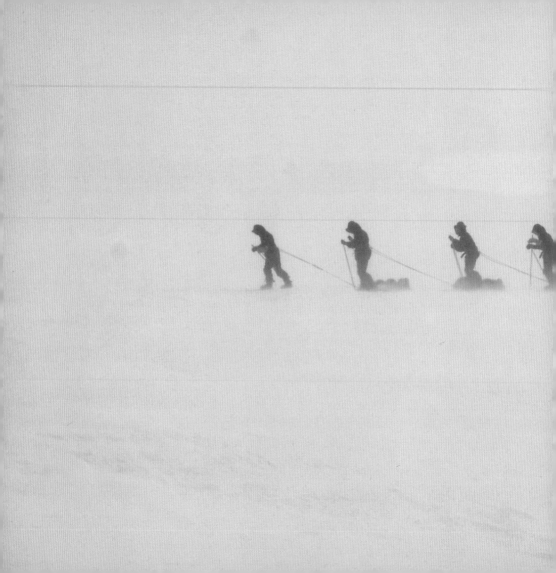

WHITEOUT! A whiteout is an apt term used to describe the optical atmospheric condition in which an observer is engulfed in a uniformly white, disorienting glow. Neither shadows, nor horizon, nor clouds are discernible; orientation and a sense of depth are lost, and dark objects appear to float at some indeterminable distance. The polar regions are host to whiteouts, in which both scattering and reflection play a large role. Beneath a uniformly overcast sky in which cloud droplets scatter white light in all directions, and above an unbroken snow cover in which light is reflected skyward, the amount of light in the sky equals that from the snow surface, and the observer becomes lost in light. Participants in the 2006 Polar Race met such disorienting conditions on April 22 on Bathurst Island.

ANGULAR MEASUREMENTS IN THE SKY

THE CELESTIAL SPHERE
The celestial sphere is the sky map used to identify directions, locations, and points of light sources and optical phenomena.

OBSERVER: You are the center of this universe. Throughout the illustrations in this book, the observer's position is depicted by this symbol: ◎

COMPASS DIRECTIONS: north (0°), east (90°), south (180°), and west (270°) define the reference points on the horizon.

The **HORIZON** is the distant line along which the Earth and sky appear to meet.

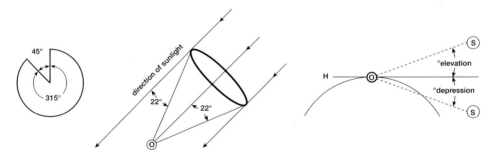

Left to right: **CIRCLE** with a 45° wedge shown. One degree (°) = 1/360 of a circle's circumference.

OPTICAL PHENOMENA of arcs and rings are expressed as the angles they form with respect to the original direction of sunlight. Primary and secondary rainbows are found at 42° and 51°, coronas vary from 5° to 10°, and halos form at 22° and 46°. The complete widths of arcs and bows as viewed in the sky are twice that size. (Note particularly that a rainbow is not identified as the angle it forms from the horizon to the top of the bow, since the elevation of the bow varies as the Sun does.)

SOLAR ALTITUDE is expressed as the angle above the horizon (H) as elevation or below the horizon as depression.

The **ZENITH** is the point directly overhead, at 90° elevation; the **NADIR** is the point directly below with a depression angle of -90°.

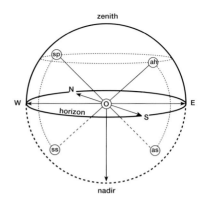

The **SOLAR POINT (sp)** is wherever the Sun is. The **ANTISOLAR POINT (as)** is the point on the celestial sphere directly opposite the Sun (180° away). The **SUBSOLAR POINT (ss)** is the point below the Sun, as far below the horizon as the Sun is above it. The **ANTHELIC POINT (ah)** is the point opposite the Sun (180°) at the same altitude. All of these points may be above or below the horizon, depending on the Sun's altitude.

OBSERVING LIGHT AND COLOR

Observing the world around us—and in particular the sky—reveals a wondrous spectacle of light, color, and action, especially if we acquaint both our eyes and our minds with what is normal and what is possible. Because we often do not recognize that with which we are unfamiliar, we may, without study and practiced observations, miss what nature has to offer. This book is therefore an introduction to what our eyes may see and to that at which our minds may marvel.

Our eyes are extraordinary sensors of our environment. Each eye has a range of view of about 200°, a response to wavelengths from 400–760 nm, and the ability to detect as little as one-hundred-billionth as bright a light as the brightest light it can endure. Our remarkable visual sensors can resolve one arc

HANDY ANGULAR GAUGE One's own hand can be used to estimate angular widths in the sky. Hold at arm's length, palm outward:

Width of:	Approximate degree of arc
little finger	1
index, middle, and ring fingers	5
fist	10
little and index fingers stretched apart	15
little finger and thumb stretched apart	25

object	Apparent Magnitude
Sun	-26.8
eye pain threshold	-19
full Moon	-12.75
first quarter Moon	-9.5
night sky	-7.5
bright aurora	-6 to -2
Polaris	2.0
limit of the unaided eye on a clear dark night	6.6
faintest yet photographed	26

APPARENT MAGNITUDE Apparent Magnitude is the measure of the brightness of a celestial object, with Apparent Magnitude 1 being exactly 100 times brighter than magnitude 6; and each whole number being 2.512 times brighter than the next. Magnitudes brighter than 0 are minus figures.

minute of angular radius (1/60 of 1°), ten nm of wavelength color, twenty milliseconds of time, and as little as a 2 percent change in brightness. The credit goes to the two kinds of photosensitive receptors in each eye: cones, which provide color vision and better spatial and contrast resolution, and rods, which allow us to see at lower levels of illumination.

Our color resolution is strongest in the center of our field of vision where the cones are located, and acuity drops off to the sides, but we remain very sensitive to motion in our peripheral sight, even if we cannot see what is moving. The rods are concentrated 10° to 20° from the center of vision, but there are almost none at the actual center. Because the rods can detect lower light levels, we can see very faint objects (such as dim stars and pale halos) better when we don't look directly at them.

Because our cones are most sensitive to the color of yellow-green and our rods are most sensitive to the intensity of blue-green, both colors near the middle of the visible spectrum, our eyes are less sensitive overall to the visible spectrum's extremes: Blue appears brighter than violet, and yellow appears brighter than red of the same intensities. Yet as illumination diminishes, and the cones become insensitive to color while the rods remain sensitive to intensities, we lose the ability to distinguish colors, and our peak vision sensitivity shifts to longer wavelengths as green and blue objects appear to become brighter than red and yellow ones.

Recording our observations of the sky in a daily log, along with notations on other factors such as time, location, solar elevation, and weather conditions, both preserves relevant facts and provides a basis for comparative studies and future revelations.

PREDICTING AND INTERPRETING VISUAL EVENTS

Becoming sky-literate is both an adventure and a journey. Only by regularly observing and comparing the events and effects we see with what is already known can we add to our overall understanding, as well as hope to be able to predict future occurrences and interpret their meanings. To this end, the subsequent chapters in this book address these issues by sorting through the common causes and effects among the various optical displays, for the delightful and practical purpose of being better able to read, understand, and enjoy the constant visual treat.

PHOTOGRAPHING FOR ART AND SCIENCE

Photographing the sky and its infinite variations of light, color, patterns, contents, displays, and conditions can be both a satisfying artistic hobby and, in the case of rare phenomena, a scientifically significant documentation.

While presenting the comparative merits of specific cameras, accessories, and film is beyond the scope of this book, we suggest you become familiar with your equipment and know how to change settings and accessories quickly and efficiently before you focus on your outdoor subject.

Keep a notepad with you to record locations, times, exposures, and other pertinent information. Sometimes even making a quick sketch can help document the subject's size, time of appearance or relationship to the Sun, horizon, or other identifying landmarks that may be outside the photo's frame. Never say, "I'll remember this." Make detailed notes at the time to be sure.

INVESTIGATING SHADOWS

Without light, there'd be no shadows. But shadows as a consequence of intense light are also optical phenomena worth investigating. Because the Sun's disk is about .5° wide (and not the point source of light that stars are), shadows from sunlight have a darker central portion called the umbra, and a lighter outer edge called the penumbra, produced as the light rays spread about .25° on each side of the overall direction. The umbra narrows and the penumbra widens with increasing distance from the object.

This dual nature of sunlit shadows is easily noticed in the dark sharpness of a tree's shadow near its trunk, and the diffuse, indistinct edges of its topmost branches farther away. Make it a point to seek out the following types of shadowy effects as part of your ongoing atmospheric investigations.

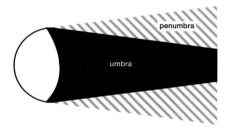

UMBRA AND PENUMBRA The angles are greatly exaggerated for illustration.

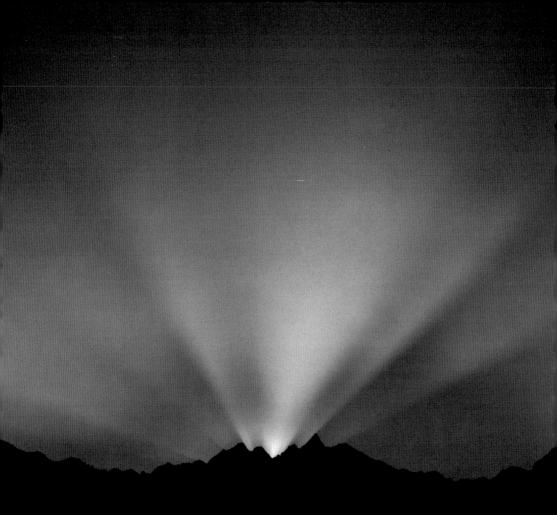

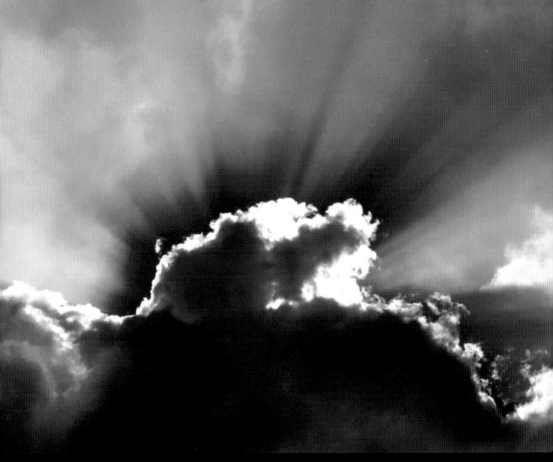

CREPUSCULAR RAYS The apparent divergence of crepuscular rays is due to our perspective. The sun's rays continue parallel overhead. Even when the sun is not below the horizon, towering clouds may also produce this same effect. Despite it not being twilight in such a case, the same term is applied. Opposite: A cold November 2000 morning near Lukla, Nepal, witnessed the Sun casting corrugated rays over the jagged Himalayan peaks of Thamserku and Kangtega. Above: The edges of a cumulus cloud radiate evening shadows

ANTICREPUSCULAR RAYS When crepuscular rays continue across the entire sky to converge at the antisolar point, such extensions are called anticrepuscular rays. Blue shadows mingle with sky pink in beaming a radiant farewell to the day over Tucson, Arizona.

CONTRAIL SHADOW The condensation of water in a jet aircraft's exhaust forms a long, narrow cloud called a contrail that usually evaporates quickly in the plane's wake. For about a minute on July 27, 2006, one was aligned perfectly to cast its shadow from horizon to horizon across the sky in Pewsey Vale, Wiltshire, England. A similar effect occurs when crepuscular

SHADOW BANDS. In the sky, look for alternating bands of shadow and light that appear to diverge in a fanlike array from the Sun's position after it has set during twilight. Produced by cloud tops that are high enough to still intercept direct rays, they are called crepuscular rays (after the Latin word for twilight). The term also refers to the pattern of rays and shadows produced by haze or towering clouds with varied edges or holes, even though the Sun is not below the horizon. Contrasting shafts of sunlight and shadow may extend downward or upward, or fan out in all directions from the cloud, depending on the position of the Sun. The apparent divergence of crepuscular rays is merely an effect of the observer's perspective.

COLORED SHADOWS. Shadows formed from white light are gray. But when the direct light falling on an object is colored, the shadow takes on its complementary hue when seen against white background light. This is an effect of our color vision rather than the presence or absence of specific wavelengths in the shadow, and it is most easily observed at dawn or dusk when the direct light from the Sun is more strongly colored than the scattered light from the rest of the sky. The direct yellow light of a clear sunset produces distinctly bluish-tinted shadows. (This is all the more noticeable on white snow.) Likewise, direct reddish sunlight creates the appearance of green-tinted shadows in the scattered white background light.

GRAND SHADOWS. When viewed from its summit at sunrise and sunset, a mountain's shadow may extend hundreds of miles. Regardless of the mountain's true shape, its shadow appears triangular in shape, due to perspective. When your own shadow is cast from a mountain peak onto a lower cloud bank, it appears much larger than it would have had it reached the ground and is called the Brocken spectre. (See Chapter 3 for more on this effect.)

As the Sun sets in the west, a shadow of the Earth's surface curvature rises in the east. At sunrise, the shadow distinguishes itself from the night in the western sky and lowers to the horizon. (See Chapter 2 for more on the Earth's shadow on the atmosphere.)

When the Moon passes through the Earth's shadow, the resultant lunar eclipse may be partial or total, and can occur only when the Sun, Earth, and Moon are in a direct line. (Since the Moon's orbit is inclined at a little over 5° to that of the Earth, lunar eclipses do not occur every month, but rather only every 346.62 days when the full Moon occurs at or close to the intersecting points of the orbital planes.) During a lunar eclipse, the Moon first passes through the Earth's penumbra, taking about an hour to reach the edge of the umbra, which is about 5,700 miles in diameter at that distance. Depending on the relative positions of the Earth and Moon, the extent and duration of an eclipse ranges from a few minutes' glancing through the penumbra to a total eclipse through the exact center of the umbra, lasting one hour and forty-seven minutes.

During a lunar eclipse, a number of observable colored effects are caused by absorption, scattering, and refracting through the Earth's atmosphere. Because red light is absorbed by ozone in the stratosphere, the outer edge of the umbra appears bluish. Blue light scattered away in the troposphere closer

to the Earth causes much of the inner umbra to appear reddish. At totality, when the Moon is completely immersed in shadow, yet is still visible because of scattered light from the Earth, its color varies from a dark gray or brown to shades of red and bright orange, depending on the amount of dust and cloud cover in the atmosphere. To see a schedule of upcoming lunar eclipses, consult the U.S. Naval Observatory's Web site at http://aa.usno.navy.mil/data/docs/UpcomingEclipses.html.

ANALYZING

Each chapter concludes with a striking photo to challenge your sky-literacy. Before reading the explanation on pages 228–229, try to interpret its meaning: See if you can identify the primary features in the photograph, how they were produced, and what the event may portend.

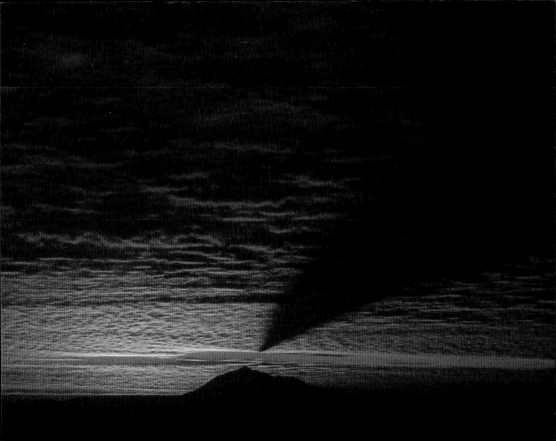

What trick of light is happening in this series of two photographs taken minutes apart?
See page 228.

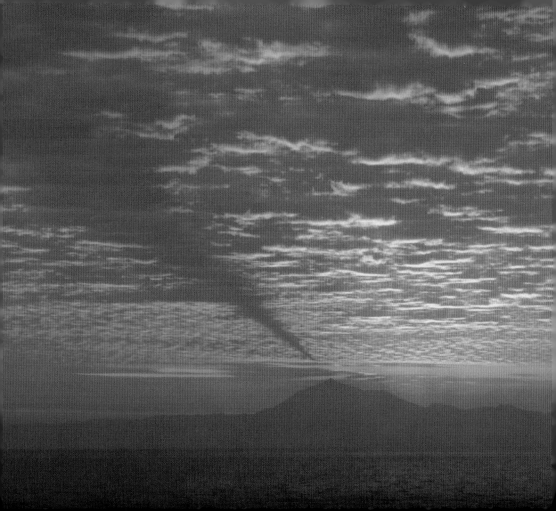

Daily Pageantry
Scenery Production, the Twilight Show,
and the Supporting Cast

The opening procession of the Sun's daily pageant decorates dawn in Maui, Hawaii,
with its signature colors.

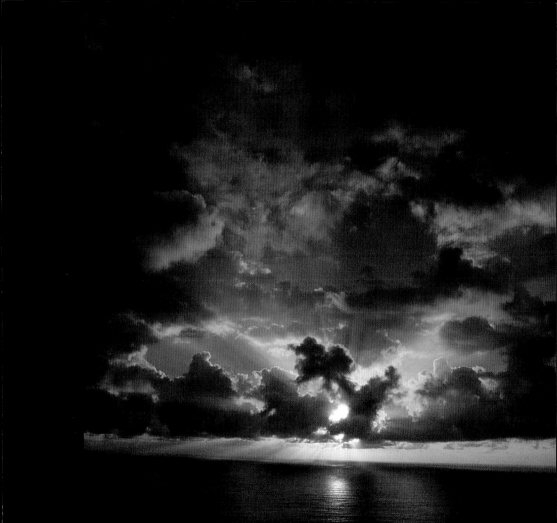

Appearing daily worldwide, the star-billed production of light saturating the atmosphere creates an elaborate and truly moving performance. At times serene, at times literally electrifying, light's mastery in merging nuance, complexity, bluster, artistry, and acrobatics produces an incomparably acclaimed daily pageant of spectacle and color.

The animated sun-splash proceeds as photons of all wavelengths exit the vacuum of space and scatter in the increasingly dense air. Shorter wavelengths are the first to split from the straight pathway, courtesy of the preponderance of nitrogen and oxygen molecules that make up the bulk of the atmosphere. In the mere microseconds it takes to penetrate the air and reach our eyes, the shortest wavelengths (violet and blue) have been scattered so many times that the sky appears blue (as do distant mountains, for the same reason). At dawn and dusk, when the light has passed through a much longer cross section of the atmosphere, most of the shorter wavelengths have been completely scattered away, resulting in the scene-stealing appearances of yellows, oranges, and reds in a spectacular sunrise or sunset.

Other players in the versicolored pageant include fine dust and ash in the air from pollution or volcanic eruptions, as well as suspended salt particles in the air over oceans, which help to create red skies. Water vapor in the air tends to absorb red wavelengths, and in the heavy concentrations before a storm, may cast an ominous, greenish pall to the air.

THE TWILIGHT SHOW

Twilight brings a twice-daily colored light show to our eyes as the Sun flirts with the horizon and smears colors, spreads shadow, and scatters light through clear air or clouds to illuminate the sky. Regardless of cloud cover, skylight decreases during evening twilight and increases during morning twilight. By definition, twilight begins when the sky is partially or completely illuminated by subhorizon light, and it is split into three sequential stages: civil, nautical, and astronomical, based on the Sun's angle below the horizon.

Civil Twilight spans the period between the moments the Sun's apparent upper edge is just at the horizon until the center of the Sun is 6° below the horizon. Under good atmospheric conditions, in midlatitudes, it lasts about a half hour; terrestrial objects are still visible.

Nautical Twilight extends while the Sun's center moves between 6° and 12° below the horizon. During this time both the horizon and the bright stars used by navigators are visible; it lasts about an hour in mid-latitudes.

Astronomical Twilight is the approximately ninety-minute period during the Sun's transit between 12° and 18° below the horizon while sunlight still reaches the higher levels of the atmosphere.

By observation, however, there are no such delineations as the twilight's main attractions appear, coincide, and flow seamlessly forward with time. The duration of twilight depends largely on the time of year and latitude (although the topography at a particular location—in a deep valley, for instance—is also a factor). At the equator, it lasts about one-and-a-quarter hours year-round, but near the poles it may last as

long as twenty-four hours, or not occur at all. The rate of change in daylight is generally steady, although a partly cloudy or overcast sky can cause some sudden fluctuations.

OBSERVING TWILIGHT

As twilight progresses, the color and luminance in a clear sky changes in interesting and complex ways, while a thickly overcast sky simply grows bluer in evening and paler in morning. The following production notes on pages 45–49 describe the typical opening and closing acts of the daily "Twilight Show" in clear air on dual stages as the Sun sets in mid-latitudes; its distance above or below the horizon is noted as its elevation or depression in degrees. The opposite sequence is observed at dawn.

CLOUDS IN THE SKYSCAPE

Clouds in the sky are primarily illuminated by the Sun and partly by light scattered to the Sun from the sky and other clouds. Their color and brightness depends on the angle of the Sun, the condition of the sky, the size and density of the clouds' droplets, and the position of the observer. On the clouds' surfaces, where light is intercepted, all the light-bending actions contribute: Scattering, diffraction, refraction, and reflection are all bit players in the cloudscape.

On the smallest scale, cloud droplets are not choosy over which wavelengths to scatter; all wavelengths are treated equally. Such nonselective scattering displays white light. Diffraction about the edges of a cloud may bring a silver lining and iridescence. Refraction through cloud droplets may show in a cloud bow. But most of the light we see from a cloud has been directly reflected to our eyes from the Sun, and is determined by the size and density of water droplets on the cloud's surface. The smaller the droplets, the greater the collective surface area of the cloud, and the greater the amount of light that's reflected. The larger the droplets, the less total surface area, and the less total light is scattered, resulting in the darker color of cloud bases and scud. Apart from these processes, a cloud may appear dark or black when it is simply so thick that light cannot penetrate it.

Some of the most spectacular sunset productions are those with a substantial supporting cast of clouds in various roles—contributing in no small way—harmoniously reflecting all the shifting kaleidoscopic shades of twilight in a brief, but beautifully orchestrated, exit bow.

ONCE UPON A SELECTIVELY SCATTERED PROVERB Once in a blue Moon, certain particles suspended in the air (such as smoke from forest fires) in just the right size, height, and thickness, selectively scatter away the red end of the spectrum, and allow a straight pass-through for blue light. When this rarity occurs, light from the Moon shines blue.

A Blue Moon (in name, not in color) refers to a second full Moon in one calendar month, which happens on average once every two-and-a-half years or so; hence the phrase's use for an uncommon occurrence.

Twilight lasts longer when the angle the Sun's pathway makes with the horizon is more oblique than when it is more vertical. At the equator, this angle is large and the Sun quickly crosses the horizon; but at high latitudes, this angle is small and the Sun, while moving at the same rate westward, changes its elevation much more slowly. These two time-lapse photos show the ecliptic of the Sun in spring in central Italy (above) at 42° N and in summer in Finland (opposite) at 60.5° N.

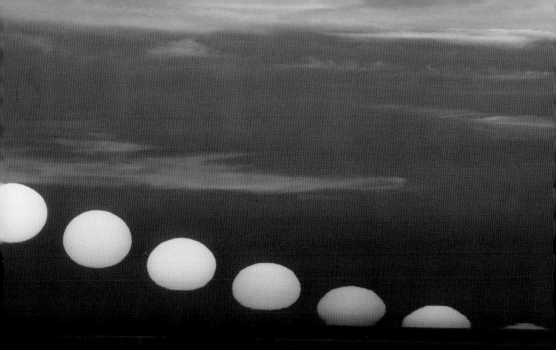

The Twilight Show

West Stage	East Stage
Approximately thirty minutes preceding sunset solar elevation 5° to 0°	
The light blue of the sky pales to a band of diffuse yellow or orange on the horizon. A bright whitish or yellowish glow of about 10° radius centers on the Sun. The instant the Sun's upper rim disappears below the sea-level horizon is the regarded time of sunset.	Clouds near the horizon take on a soft red glow, and the sky spreads colors with height from light orange to yellow to blue.

Luminous bands of red-orange, yellow, yellow-white, gray, and blue blend and stack on the horizon.

Centered on the lowering Sun, the top segment of the bright glow still visible gives way to a rose-red spot that expands into a widespread purple glow, extending 40° to 80° in width and upward to as much as 20° above the Sun. The luminosity of this purple light is a joint effect of two types of light scattered into our vision: the reddish light scattered by the turbid layer of the atmosphere between twelve and nineteen miles; and the bluish light scattered by molecules higher up in the atmosphere. Its maximum intensity occurs about twenty minutes after sunset, when the Sun is about 4° below the horizon. The top of the purple light descends toward the horizon until the solar depression reaches 7°.

High cloud tops far enough away from the observer to intercept sunlight in the purple light region cast shadows known as crepuscular rays. Appearing as alternating light and dark bands, these twilight rays diverge in a fanlike array from the solar point.

Stars of the first magnitude become visible.

The clear western sky glows orange, rose-red, and purple forty-five minutes following sunset near Seattle, Washington.

A curved bluish-gray band of light rises from the eastern horizon. This is the earth shadow, and displays the Earth's curvature quite well. The greater the amount of haze in the atmosphere, and the brighter the sunlight arriving from the west, the more visible and distinct this dark segment appears. Rays skimming the Earth's surface in the lowest, most turbid layer of the atmosphere are the first to be obscured, followed by those at increasing heights as the earth shadow rises and the Sun continues to sink below the horizon.

Just above the edge of the earth shadow appears the countertwilight arch, also known as the Belt of Venus. Between 6° and 12° in height, this glow blends gray to red to yellow to blue, and is produced by the back-scattered light that has passed through a long path in the upper atmosphere. It more often appears as a pinkish yellow to purplish band of light for the same reasons as the purple light of the western sky. The countertwilight rises with the antisolar point, the spot on the celestial sphere directly opposite the Sun.

Above the countertwilight is a brighter area of light known as the bright reflection, a widespread diffuse reflection of the Sun's light in the west. It appears for about fifteen minutes until the Sun drops about 3° below the horizon.

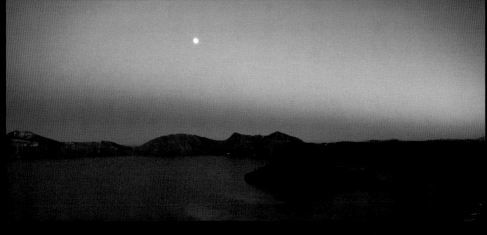

A clear southeastern vista over Crater Lake, Oregon, hosts the rise of the earth shadow, countertwilight arch, and bright reflection thirty minutes after sunset. A nearly full Moon graces the peaceful tableau.

The top of the purple light fades, and the twilight glow begins. This faintly glowing band is only a few degrees high, but visible over 20° to 30° of horizon, as the solar depression angle increases from 7° to 18°. From this position, only the particulate matter high enough in the atmosphere to be directly illuminated by the Sun scatters any light in our direction, causing the glow.

The faint purple ceases when the Sun's rays just skim the top of the optically effective atmosphere, at a height of thirty to thirty-eight miles. Collectively, the purple light, the twilight glow, and all the other hues of the western twilight are known as the afterglow.

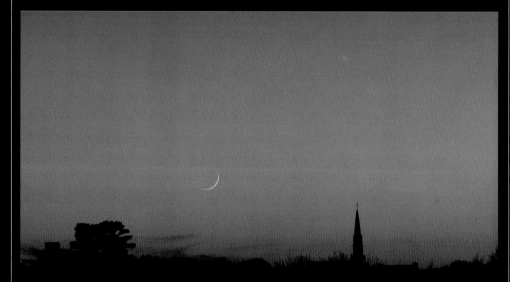

A twenty-seven-hours-old crescent Moon settles with the twilight glow over Rostronën, France in a clear western sky one hour after sunset.

The earth shadow appears to rise more rapidly than the Sun sets, becoming less distinct as it reaches 10° to 12° above the horizon.

The countertwilight arch dims, and its boundary with the dark earth shadow disappears into night.

Stars up to the fifth magnitude become visible.

The pastel pinks and blues of the clear eastern sky blend and dim to a dark blue-gray forty-five minutes after sunset as stars begin the night shift over central New Mexico.

A wide-angle lens with a polarizing filter takes in the entire sky over southwest Finland and reveals the polarized nature of skylight as waves scatter at 90° from the Sun (top, behind trees) resulting in the darkest spot in the sky.

← A clear blue sky is not uniformly blue. Light from the horizon, in a longer pathway through the atmosphere, is scattered (and rescattered) many more times than in its shorter line of sight from the zenith. As a result, all wavelengths eventually strike air molecules and are scattered and blended into the white light we see at the horizon, as noted near Spook Canyon, New Mexico.

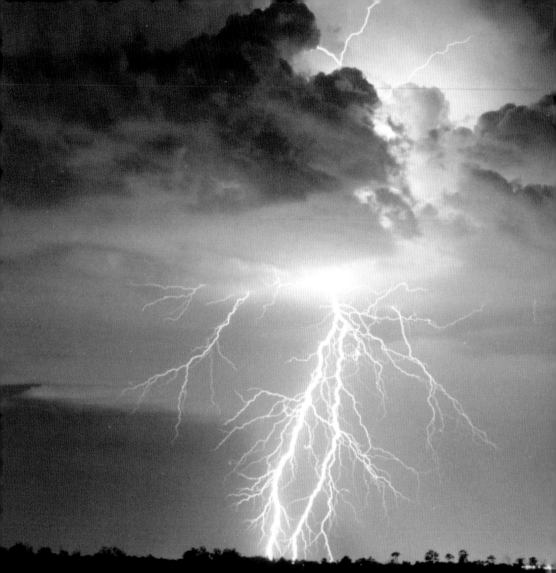

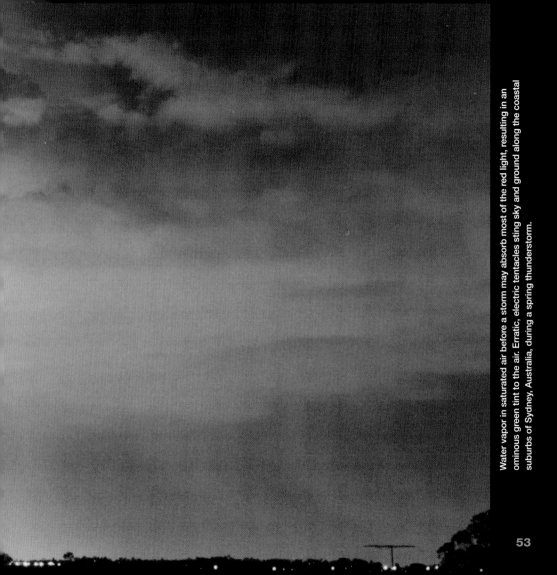

Water vapor in saturated air before a storm may absorb most of the red light, resulting in an ominous green tint to the air. Erratic, electric tentacles sting sky and ground along the coastal suburbs of Sydney, Australia, during a spring thunderstorm.

53

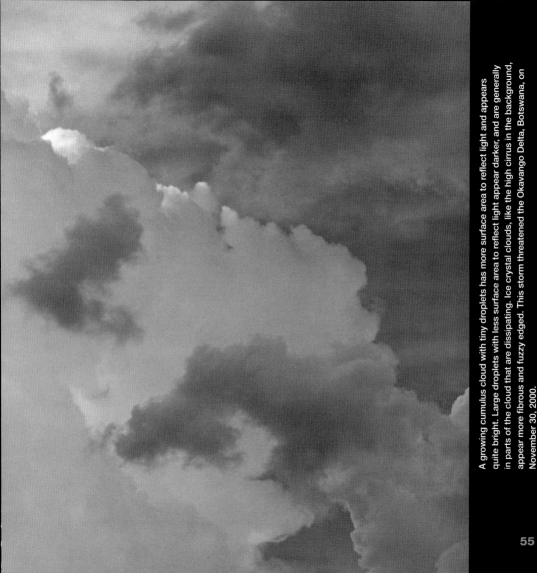

A growing cumulus cloud with tiny droplets has more surface area to reflect light and appears quite bright. Large droplets with less surface area to reflect light appear darker, and are generally in parts of the cloud that are dissipating. Ice crystal clouds, like the high cirrus in the background, appear more fibrous and fuzzy edged. This storm threatened the Okavango Delta, Botswana, on November 30, 2000.

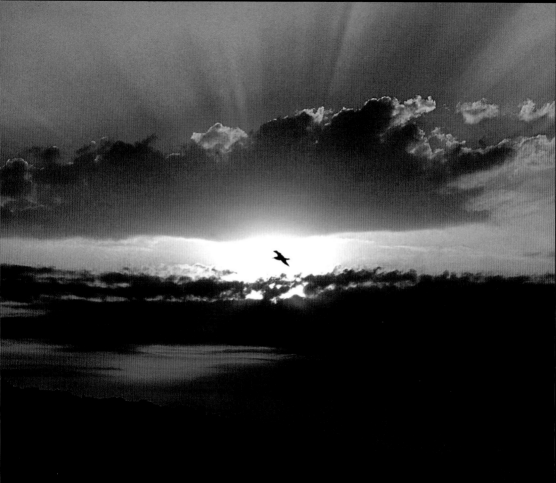

The grand finale of the daily pageant autographs an original masterpiece in glowing terms near Pisa, Italy.

← Diffraction around the small water droplets of a cloud reveals pastel patterns of iridescence over Juva, Finland.

57

ALPENGLOW Occasionally on a mountain summit, the colors of sunset reappear soon after sunset or before sunrise. Dubbed alpenglow, this effect begins when the peak is basking in the pinkish-yellow glow of direct sunlight, even though the Sun has already sunk below the horizon in the valley. As the countertwilight arch rises and reflects from the slopes, it adds its illumination to the Sun's direct rays, creating a well-lit summit contrasting strongly (especially if it is snow covered) with

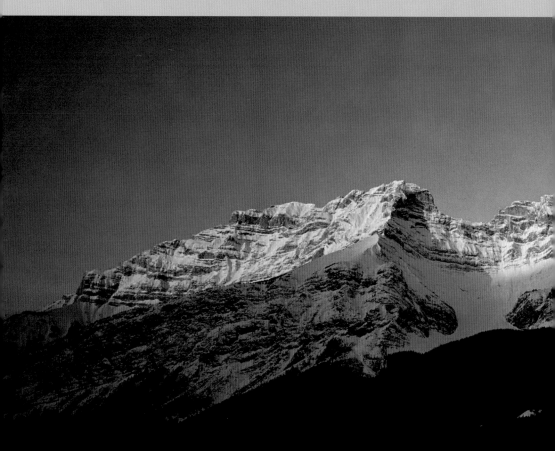

a deep-blue sky and the darkness of the earth shadow. As the Sun sinks farther (-5° to -9°), the peaks lose the direct sunlight and become awash in a fading yellow-to-purple light, before being extinguished by the rising earth shadow. This sunrise alpenglow on Cascade Mountain in Banff National Park, Alberta, Canada, is much less common than its evening version, and tends to cast more pink-and-purple hues.

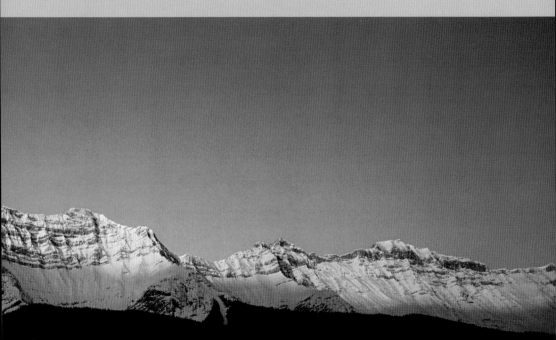

IRIDIUM FLARE From a number of small communications satellites owned by Iridium Satellite LLC come predictable, dramatic, and nonnatural nighttime glints of reflected sunlight, as their main antennae of highly reflective flat aluminum plates catch rays and fling them earthward. The flares may last five to twenty seconds and flash up to thirty times brighter than Venus.

This flare flashed a Magnitude -6.4 from Iridium 58 on August 29, 2006, as seen from Quimper, France. The stars created short trails in the forty-seven-second exposure.

ZODIACAL LIGHT Tiny dust particles outside the atmosphere scatter sunlight that can be seen as a faint nighttime glow known as the zodiacal light, best observed in autumn just before dawn or in spring just after dusk. This image was captured with a forty-second exposure near Elmberger Alm, Austria.

ZODIACAL LIGHT: THE LATE / EARLY SHOW

After twilight has faded in the evening, and before it begins in early morning, yet another display of heavenly light shines forth for about ninety minutes. Emanating from the Sun below the horizon, the zodiacal light is a faint, triangular-shape glow of light, broadest at its base, that extends 60° to 90° along the ecliptic (the apparent path of the Sun against the background of the stars). Formed by sunlight scattered by tiny dust particles in the solar system, it is brightest toward the Sun (about the intensity of the Milky Way) and fades with distance.

The source of this dust is tiny particles from comet emissions and collisions in the asteroid belt known as the interplanetary dust cloud, which permeates the inner solar system out to the orbit of Jupiter. The particles are less than a hundredth of an inch in size and are typically separated by about five miles in distance. As sparse as that seems, however, zodiacal light—in the absence of the Moon—contributes about 60 percent of the illumination in the nighttime sky.

In mid-latitudes, zodiacal light is best seen in the autumn morning about ninety minutes before sunrise or in the spring evening about ninety minutes after sunset. It is during these times, near the equinoxes, when the ecliptic is most vertically inclined relative to the horizon. From lower latitudes, viewing conditions are more favorable year round.

On a particularly clear night, without any contributing light from the Moon or other sources, another subtle glow can be found at the antisolar point. Known as the *gegenschein* or counterglow, and caused by the same process as the zodiacal light, it is an oval patch with its long axis extending along the ecliptic, with a width of about 6° and a length of about 10°. Having about the same brightness as the fainter parts of the Milky Way, the glow is best seen after midnight when it is high in the sky. In the Northern Hemisphere, the best times are when it occurs in a part of the sky with fewer stars, from late September to early November, and again from late January to early February.

Under exceptionally clear and dark conditions, the *gegenschein* is connected to the noticeably brighter zodiacal light along the ecliptic by narrow, faint extensions called the zodiacal bands. Because of their relatively large sizes and faintness, the zodiacal light and the *gegenschein* cannot be detected with binoculars or telescopes; they can only be seen with unaided, dark-adapted eyes.

PREDICTING DAYLIGHT VIEWING CONDITIONS

Because the Earth rotates and revolves about the Sun in an orderly, predictable pattern, we can predict the times of sunrise, sunset, and twilight periods as they vary over the course of the year; however, this kind of work is not for the amateur observer. Such calculations are published and easily accessible from most almanacs as well as many daily newspapers and weather- or astronomy-related Web sites.

Keep in mind that such tables usually give times as Universal Time (UT) based on the prime meridian through Greenwich, England. Hours must be added or subtracted to convert to your longitude, including Daylight Saving Time, if applicable. Even so, such calculations are only approximations, since a one-hour

passage of the Sun covers 15° of longitude, but generally an entire time zone; as a consequence your local solar time will vary.

The best conditions in which to observe the natural daylight colors are in clear, dry air, and most weather forecasts can accurately alert you at least a day in advance.

The Clear Sky Clock Web site (http://cleardarksky.com) offers forty-eight-hour forecasts of sky conditions for over 2,600 locations in North America. Designed for amateur astronomical viewing, but worthy for daytime consultations as well, the color-coded graphic is prepared from numerical weather predictions of the Canadian Meteorological Centre, and displays hour-by-hour forecasts of cloud cover, transparency (visibility), darkness, wind, humidity, and temperature, all of which can affect viewing conditions.

INTERPRETING SKY COLORS

The Sun's visible radiation reaches our atmosphere as pure, unpolarized white light consisting of every possible wavelength of color. As it filters through the air and water molecules, and is scattered, diffracted, reflected, and refracted on its way to our eyes, its eventual hues and configurations can offer clues to both current and future conditions. A few reliable weather proverbs speak to these observations.

> *Evening red and morning gray*
> *Helps the traveler on his way.*
> *Evening gray and morning red*
> *Brings down rain upon his head.*

Because our weather systems in the Northern Hemisphere generally move from west to east, reddish light arriving from the west through a dry evening sky foretells more of the same. And morning cloudiness—producing a gray dawn—likely means that the rain has already passed. Conversely, if the evening is gray, rain may be on its way.

> *When day is dry, the mountain view*
> *cross valley stream and sky of blue.*
> *When day is wet, the mountain sleeps*
> *neath foggy mist and sky that weeps.*

Drier air is usually clearer air, affording greater visibility of distant objects. With higher humidity, visibility decreases; as it reaches saturation and mist forms, the sight distance is greatly diminished. Warmer air generally transports more water vapor than cooler air. Very cold air usually contains very little moisture and is exceptionally transparent, allowing sharp viewing of distant objects; therefore:

*Cold is the night
When the stars shine bright.*

On the other hand, dry air that stagnates often becomes hazy with dust and aerosols, and the movement of a coming low pressure system clears the air before a storm. This is especially true with the haze of airborne salts over the ocean's surface. Hence the following seemingly contradictory proverb from the old-time mariners is also true:

*The farther the sight,
The nearer the rain.*

Dust and smoke particles suspended in the air selectively scatter red light (longer wavelengths) more than other colors, and offer more opportunities for moisture in the air to condense or crystallize on them, forming clouds. When moonlight passes through dust-laden air, it appears reddish; when it filters through clouds, it pales. When the air is dry and clear, the Moon reflects the white light of the Sun well. Consequently:

*Pale Moon rains; Red Moon blows.
White Moon neither rains nor snows.*

ANALYZING
What remarkable set of circumstances has glazed this evening sky? See page 228.

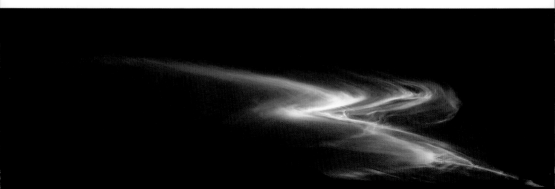

Many-Splendored Rings

Rainbows, Coronas, and Glories

A primary rainbow with several supernumerary arcs and a reverse-spectrum secondary bow paints the sky opposite the sunset in Redmond, Washington, on July 8, 2005. A high concentration of uniformly sized raindrops produces the bright bands and strong supernumerary bows, while the concentration of light within the primary bow reveals the extent of scattering from the low Sun on the distant clouds.

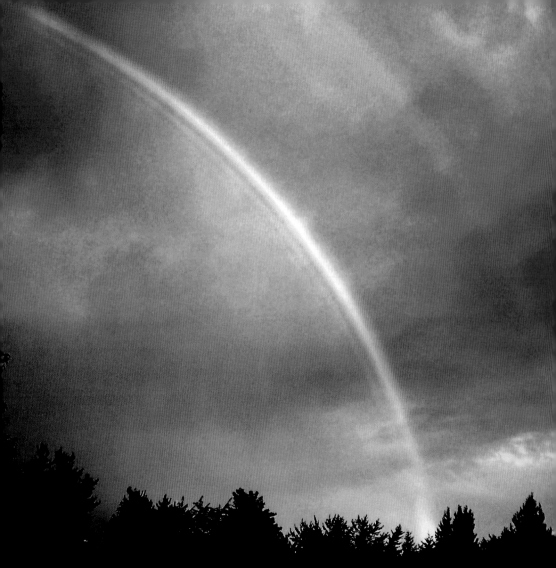

While the parading pageantry of colored skies both begins and ends with the
Sun's daily transit, light's trajectory through the air's film of water adds another glossy dimension to the masterpiece. Projected through various sizes of droplets and scattered, diffracted, refracted, and reflected, the prismatic light paints a fascinating tableau of watercolored rings amid the changing and capricious weather.

The most well-known apparition of this type is the exceedingly beautiful and complex rainbow, whose aura and mystique have tantalized observers since ancient times. In the Judeo-Christian heritage, its origins are attributed to God and His promise of mercy to humankind after the Flood. The Greeks and Romans called it the insignia of Iris, messenger of the gods. Amerindians regarded the rainbow as a gift from the Sun god, while Norsemen regarded it as the gods' tricolored bridge from Earth to their heavenly residence in Asgard. Celtic folk developed and associated fairy tales with pots of gold found at its ends. Modern Western discernment extends its use as a symbol for unity of peoples, religions, cultures, and lifestyles. Both as a natural phenomenon and a cultural symbol, it truly is an all-encompassing and over-arching radiance, known and cherished by all.

Yet the rainbow, as ubiquitous as it seems, is not the only model of brightly banded color displays. Its class of water-based light forms includes variations on its own theme, as well as an order of concentric rings and auras centered on the Sun, Moon, and even our own heads.

CORONAS

When diffraction works alone, it can divide light into distinct bands of separated colors, depending on the size and type of its media. When light from the Sun or Moon passes through the very small water droplets of mist, fog, or a thin cloud, it diffracts and disperses in a concentric series of small rings, called a corona, surrounding the Sun or Moon. In each band's sequence, the color of the innermost ring is violet or blue, with green or yellow following, to red on the outside, and is produced as the light diffracts around droplets of fairly uniform size.

The radius of a corona is inversely proportional to the diameter of the water droplets: the smaller the droplets, the larger the rings. Thin altostratus clouds and young clouds, which have the most uniform droplet sizes, produce the purest and best separation of colors, resulting in spectacular coronas. Occasionally, frozen droplets or the very small ice crystals of cirrus clouds may produce a corona.

A poorly developed corona, characterized by a bluish-white disk immediately around the Sun or Moon, with a reddish-brown edge, is called an aureole. It is usually not more than 5° in radius (but may range from 2° to 10°) and is formed when the cloud producing the diffraction is composed of a wide variety of droplet sizes. Because most clouds have this characteristic, aureoles are more frequently observed than coronas.

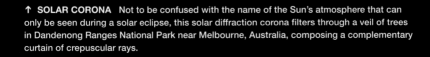

↑ **SOLAR CORONA** Not to be confused with the name of the Sun's atmosphere that can only be seen during a solar eclipse, this solar diffraction corona filters through a veil of trees in Dandenong Ranges National Park near Melbourne, Australia, composing a complementary curtain of crepuscular rays.

↗ **AUREOLE** Light from the Moon diffracts through thin altostratus clouds, while Jupiter makes an appearance at the top edge of the red-brown aureole over Seattle, Washington, on November 12, 2000.

PREDICTING AUREOLES AND CORONAS Since aureoles and coronas are associated with thin altostratus and fogs, knowing when and in what conditions they occur can give us a heads-up for possible sightings.

If over the period of a day or so, you note high cirrus that thicken and lower, the next likely cloud pattern to form is altostratus, as the layer of air continues to sink and clouds condense. As a mainly featureless grayish or bluish cloud sheet, having parts thin enough to reveal the Sun at least vaguely, altostratus offer the uniformly small droplets conducive to coronas.

The most common fog forms overnight in still, moist air as the Earth radiates heat and the air cools. Called a radiation fog, it occurs most frequently in valleys where cool air accumulates after draining down hillsides. Another type of fog forms when moist air flows over a cold surface, as it does at sea. As long as the fog is not too dense, and the light from the Sun or Moon can penetrate it, look for a corona.

INTERPRETING AUREOLES AND CORONAS

A ring around the Sun or Moon
Means that rain will come real soon.

The appearance of a corona or aureole is the unmistakable tip-off to the presence of moisture in the air. When that form of moisture is a bank of altostratus, it may, in turn, be an indication of the approach of a warm front, which could bring precipitation within twenty-four to forty-eight hours.

RAINBOWS

Aristotle was perhaps the first deep thinker to ponder the rainbow's arc, and the person who confidently but wrongly attributed it to the rain's reflection of the Sun's rays. René Descartes, in 1637, tackled the enigma by simplifying his study to one droplet and how it interacts with light. Experimenting with a large water-filled glass globe as the droplet's substitute, he fairly accurately described the rainbow's basic mechanics.

The familiar spectral arc of the rainbow is produced by refraction and reflection inside individual rain-drops falling in a sheet, and comes in several varieties. For a rainbow to occur, the Sun must be shining in one portion of the sky, and rain falling in another portion. For a rainbow to be observed from the Earth's surface, the Sun must be at the observer's back, and the rain in the opposite direction.

As light enters a raindrop, it refracts, separating into its spectrum colors, bending shorter wavelengths (violet) more than longer wavelengths (red). If the angle between the refracted light and the inside back

surface of the raindrop is less than 48°, the light simply passes through the back of the drop, refracting once again upon exiting. No light is received back to our eyes and nothing is observed. (This angle is called the critical angle for reflection in water—it is different for other substances.) If the light strikes the back of the drop at an angle greater than 48°, light is reflected back. The reflected light is refracted as it exits the drop, again bending violet light more than red light, resulting in an approximate 2° dispersion of color between about 40° and 42° relative to the incoming sunlight, and we observe the arc of the primary rainbow, with red on the top or outside of the arc, and violet on the bottom or inside of it.

The primary rainbow may be thought of as a cone of concentrated light bounded by spectral bands. The arc is always centered on the antisolar point at the head of the observer's shadow, 180° from the Sun. Light passing through drops inside the cone brightens the sky inside the cone; light passing through those outside do not. To witness the complete ring, we must move to a height above the rainfall, thus lowering our horizon.

Light entering at the top of a drop is refracted, reflected off the inside back surface, then refracted again as it exits the drop, having been bent a total of about 138°. Light entering near the bottom of a drop refracts, reflects twice internally, then refracts upon exiting the drop, having been bent a total of about 231°. The differing color sequences between the primary and secondary bows are produced in the same way: Violet is bent more than red.

Each drop in the sky produces all the colors of the rainbow, but we do not see them. Instead, only the drops situated at the vertical angles of about 42° and 51° refract their dispersed light toward our eyes. Of that, just one color from each drop is deviated at just the right angle for us to see, and thus is only a fraction of the total bow observed. Higher drops collectively contribute to the secondary bow; lower drops to the primary bow. Each person sees his or her own rainbow.

Because of the various angles

RAINBOW CONSTRUCTION

51°

42°

direction of sunlight

horizon

antisolar point

O

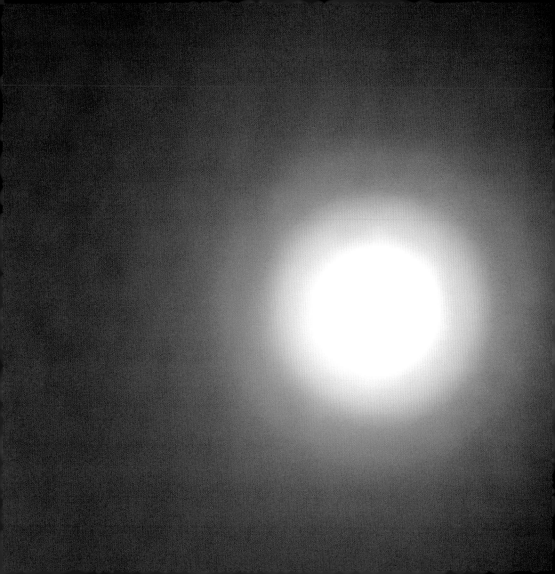

LUNAR CORONAS Coronas are more easily observed in moonlight than sunlight because of the Sun's brightness. At times up to three coronas, each with its series of blue-green-red rings, may concentrically appear around the aureole, forming what is called a four-fold corona. Approaching that benchmark is a lunar aureole and two very strong coronas with a very faint, partial third over Cologne, Germany, in thin altostratus on January 28, 2002.

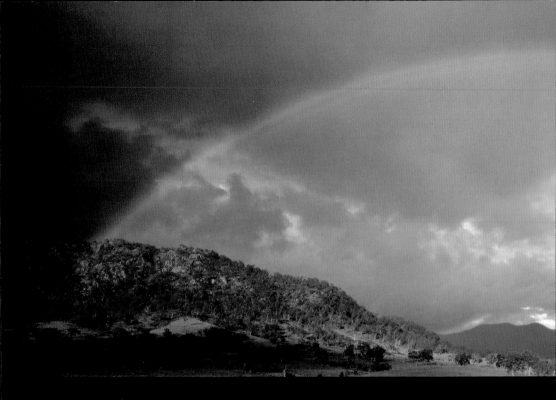

The delightful arc of a rainbow's bright ribbon is merely the outer edge of a cone of redirected and concentrated light centered on the antisolar point; here projected on the land and sky near Bega, New South Wales, Australia. A late afternoon summer storm in January 1989 crafted the scenic skyscape.

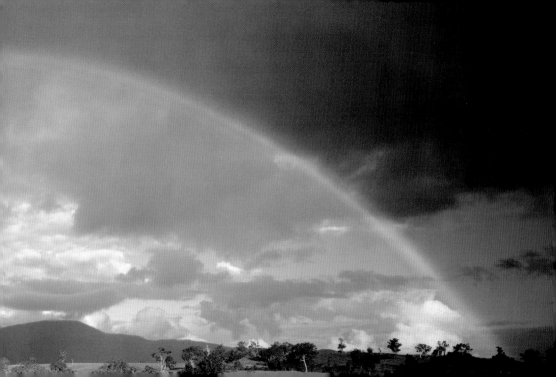

of the color dispersion, only one color of light can be observed from any one drop, and no two observers can see exactly the same rainbow. To observe a full rainbow, an incalculable number of raindrops must be falling in the sunshine to create its attention-grabbing magnificence. In heavy rainfall, the bow may spread across the sky and seemingly rest its ends on the ground (which once led a certain young boy to run down the country road looking for that proverbial rainbow's end—I was so close!). But the rainbow, as seen from the ground, exists only as light bent in certain angles as it reaches the eyes, and is always centered on the head of the observer's shadow, the antisolar point, 180° from the Sun. Yet from our angle on the ground, the rainbow is just a fraction of what is actually created. A view from above the falling rain reveals the visual thrill of a complete 360° circle!

Inside the 42° arc, the sky is noticeably brighter than outside the bow. Because there are many light rays emerging from raindrops at angles less than those that contribute to the bow itself, but virtually none at greater angles from the single internal reflection, light is concentrated inside the primary bow. As a mix of all the rainbow's colors, it appears white.

SECONDARY RAINBOW

At about 51° a fainter arc of color about 2.5° wide forms from two refractions and two reflections inside raindrops. The secondary rainbow displays the opposite color scheme of the primary bow, with red on the inside and violet on the outside, having, in effect, turned the color dispersion inside out through about 231° to get to our eyes. Secondary bows are less bright than primary bows because more light energy is used in the double reflection. Often no secondary bow is produced because the non-spherical nature of larger raindrops considerably distorts the light path.

When two bows are present together, the sky between them is noticeably darker than above and below them. Because of the inverted way the secondary bow is created, there are many light rays emerging from the two internal reflections at angles greater than those that create the bow, but none at lesser angles. Combined with the primary bow's absence of light in this same area, the dark region between about 42° and 51° is called Alexander's Dark Band, in honor of Alexander of Aphrodisias, who first described it nearly two millennia ago.

SPECIALTY BOWS

The individual sizes and shapes of raindrops comprising the shower affect the brightness of the rainbow. Showers with the greatest numbers of large, spherical drops produce symmetrical bows with the most vivid colors. But not all raindrops are spherical. As typical droplets (about 1.3 mm in diameter) grow by bumping together and coalescing as they fall, the drag of the air on the largest drops (exceeding 5 mm) flattens them on their tops and bottoms to a shape more like that of a hamburger bun. (No raindrops are ever teardrop shaped!) When light passes through these larger, flattened drops, some of it is lost to our vision, and we see the rays that have passed through them only when we view the drops horizontally.

A rainbow may appear to end at a nearby location, but that end can never be reached. In an afternoon of sunshine and showers, this bright-banded specimen blossomed over Pewsey Vale, England, on October 1, 2005. A bit of thicker clouds near the bottom seems to ripple the bow and shadow its interior with faint shafts extending toward the antisolar point, like spokes on a wheel. The fortuitous gull will never know it lent its graceful silhouette to the scenic portrait.

A high enough perspective reveals the thrilling sight of the rainbow's entire cone of concentrated light within its spectral border. On December 1, 2004, from about 1,000 feet over Hawai'i Volcanoes National Park, and some 4,500 feet above sea level, Ron Chapple leaned far out of a helicopter to record this fantastic apparition using a wide-angle lens. A very faint secondary rainbow encircles the primary's perimeter.

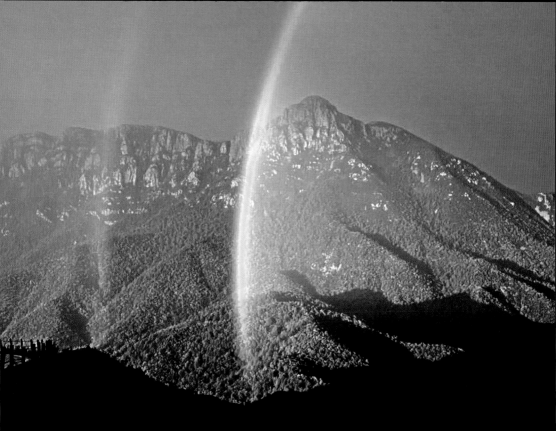

ALEXANDER'S DARK BAND Scenic Mount Wrightson in southern Arizona stands sentry for a sharply defined double rainbow on January 14, 2001. The sky between the parallel arcs is noticeably darker as less light is directed between them than inside the primary bow and outside the secondary bow.

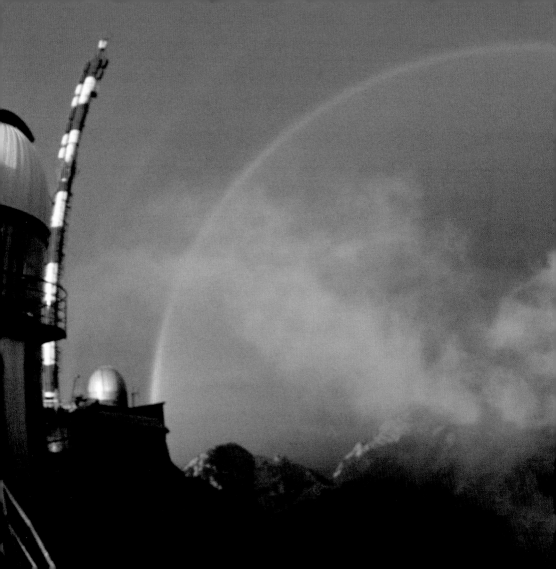

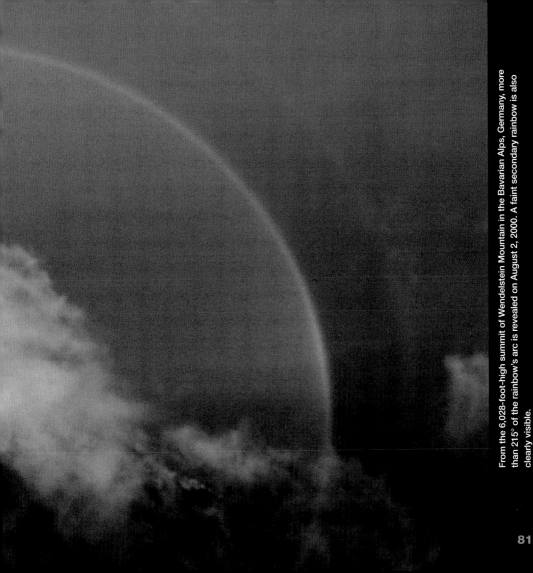

From the 6,028-foot-high summit of Wendelstein Mountain in the Bavarian Alps, Germany, more than 215° of the rainbow's arc is revealed on August 2, 2000. A faint secondary rainbow is also clearly visible.

LOCATING AND OBSERVING WATER-DROPLET RINGS

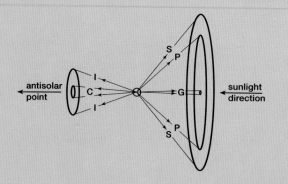

WATER-DROPLET OPTICS MAP The diagram maps out where the various displays form relative to the positions of the Sun (or Moon) and the water droplet. To see them, however, you must vary your position with respect to the Sun and the droplet.

FACING AWAY FROM THE SUN To see rainbows (P-primary; S-secondary), glories, and *heiligenschein*, (depicted collectively as G) you must be between the Sun and the droplets, with your back to the Sun.

RAINBOW To more precisely locate your rainbow, stand with your back to the Sun and find the head of your shadow—this is the antisolar point and the center point of the rainbow's cone. Stretch out your arm and point your index finger at your head's shadow. Hold out your thumb at an approximately 42° angle (half a right angle) and pivot your wrist while keeping your index finger aimed at your head. Your thumb traces out the direction of the arc; take note of where the rainbow meets the horizon.

 The rainbow never gets any higher in the sky than when the Sun is at its lowest. At sunrise or sunset, when the Sun is on the horizon, the rainbow is a full-half circle high. As the Sun rises, the bow, which is always centered on the antisolar point, sinks. When the Sun reaches 40° elevation, just the top of the rainbow can be seen resting on the ground. The best times to observe rainbows are usually in the early morning or in the late afternoon when the Sun is relatively low.

GLORY AND *HEILIGENSCHEIN* These surround the antisolar point, where the head of your shadow falls, and are more often noticed when the Sun is higher in the sky.

FACING THE SUN To see coronas and aureoles (shown collectively as C) and iridescence (I), you must face the Sun (or Moon), with the droplets between you and the Sun (or Moon).

CORONAS AND AUREOLES These are generally 5° to 15° in width and surround the Sun or Moon. Stretch out your arm and cover the Sun with your fist to block its brightness. The width of your fist is about 10° and marks the general boundaries of the rings.

IRIDESCENCE Iridescence on clouds may be found up to 45° away from the Sun in any direction.

← **LOW BOW** A spectral footbridge spans the valley near Loch Awe, Scotland, on April 18, 2006. With the Sun at 40° high, just the top of the primary bow skims the landscape, while the secondary bow bridges the ridges. Because the rainbow is centered on the antisolar point, a high Sun splashes a low dome on the ground and the Sun at the horizon inscribes a full half circle in the sky.

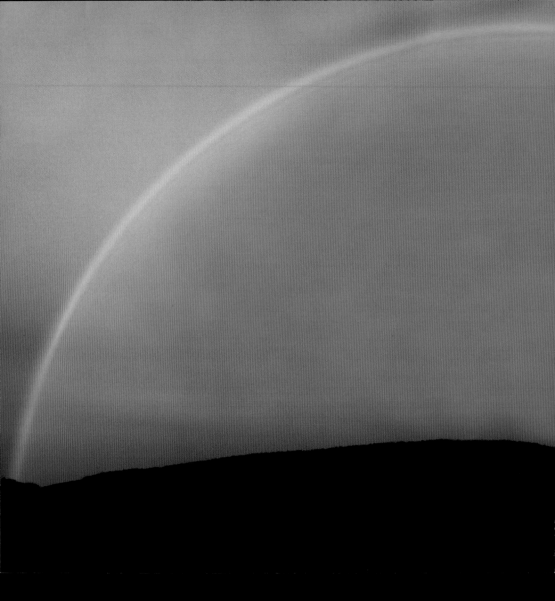

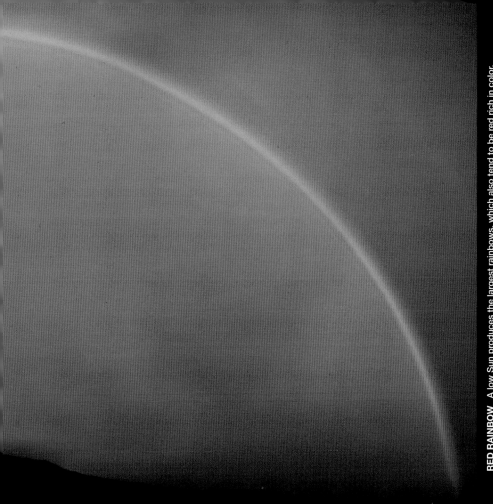

RED RAINBOW A low Sun produces the largest rainbows, which also tend to be red rich in color. The long pathway through the lower atmosphere scatters the shorter wavelengths of blues and greens, leaving the remaining light proportionately higher in the longer wavelengths of yellows and reds. This giant orange slice flavored the day's end in Istanbul, Turkey, on August 4, 2005.

This effect is most often noticed when the Sun is near the horizon, and the rainbow's ends, produced by these larger flatter drops, are brighter than the top of the bow, which is produced by smaller spherical drops.

Other factors also influence the visage and apparent brightness of a rainbow. A thick rain shower with a greater number of raindrops produces more vivid coloration than a thin curtain of rain does. Dust or haze in the viewing theater can scatter the shorter blue and green wavelengths producing rich red-favored bows. In addition, the rainbow's relative contrast with the background illumination of the landscape affects its apparent brightness.

FOGBOWS AND MOONBOWS

Drizzle drops, with diameters of about .9 mm, can still produce a rainbow, but one that is more pastel in appearance. Because the drops are so small, the bands of colors begin to overlap and mix, diluting their purity. In droplets smaller than about .6 mm, the red band vanishes. Cloud droplets, being about ten times smaller than drizzle drops, produce a wider, almost colorless white bow, with only the faintest hint of yellow to the outside. Called a cloudbow or fogbow, it is also descriptively known as a mistbow or white rainbow. Occasionally, in bright moonlight, with the presence of raindrops and all the other geometrical requirements, the rainbow's pastel nighttime version, the moonbow, may be observed with its blend of softer, paler colors.

SUPERNUMERARY BOWS

In a sharply defined primary rainbow, several sets of narrow prismatic bands may be observed just inside the violet ring. Called supernumerary bows (possibly because before they were fully understood, they seemed just plain "extra"), they are caused—and explained—by diffraction at the end of the light-bending operation. Formed in the constructive and destructive interference of the light waves crossing one another as they exit the raindrop, they are narrower than the colored bands of the primary bow, and may repeat the red-to-violet sequence several times, growing narrower and fainter with decreasing radius. When the raindrops are large (greater than 1 mm) the diffraction pattern may display up to five supernumerary bows, the first merged with the primary bow, all repeating a pure red/vivid green/bright violet pattern. With drops less than .2 mm, fewer supernumerary bows form, with no red but more yellow, and a gap between them and the primary bow. Such a set of "extra" bows is also possible—but very rarely observed—on the outside of the secondary bow.

GLORY

As a complement to the corona, the anticorona, or glory, appears at the antisolar point. To see it, one must be located at a higher altitude than that of a cloud deck or fogbank; it is most commonly noted around an airplane's shadow. In appearance, it resembles a corona, with the notable difference of a dark

FOGBOW A near-perfect white fogbow joins hill and dale on a misty morning in Marlborough Downs, central Wiltshire, England, on January 22, 2006. A polarizing filter was used to improve the contrast in this photograph.

← **TWINNED BOW** As raindrops fall, they tend to coalesce and grow larger, but as they do, they also become less spherical as air resistance flattens them to a shape more like a hamburger bun. In unique and rare circumstances, a mixture of spherical and nonspherical raindrops may produce a split-branched aberration called the twinned rainbow. This specimen made a brief appearance of a few minutes during the early evening of June 3, 2002, over Cologne, Germany, before merging its anomalies into a regular rainbow with several supernumerary bows.

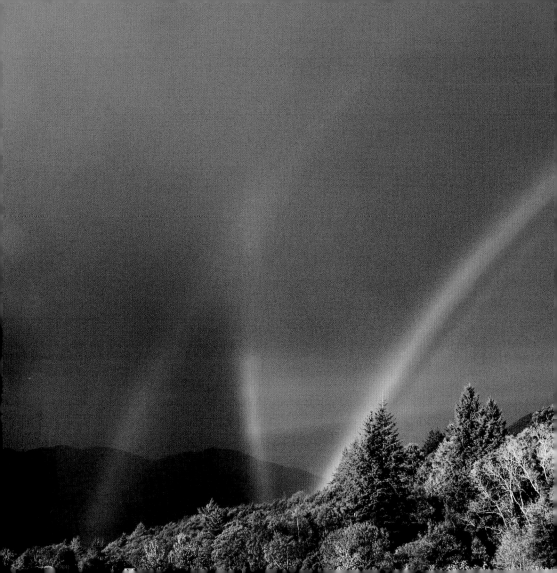

SPOKED BOW When clouds or heavy rain obscures portions of the light reaching the inside of the rainbow cone, the resultant shadows radiating toward the antisolar point resemble a sky-high wagon wheel, like this one over the Campbell River estuary on Vancouver Island, British Columbia, on June 21, 2005; its uniquely pleasing qualities attractively doubled on the water's surface. Note the difference between this reflected rainbow and the reflection rainbow on the opposite page. Jim Dubois snapped the scene with a digital point-and-shoot camera before the rain and wind hit just five minutes later and he retreated home for hot chocolate.

← **REFLECTION RAINBOW** Fanciful script is written in the sky by the combined efforts of the Sun at 12° elevation, uniform falling raindrops constructing primary and secondary bows, and a mirror-smooth lake reflecting light upward to form a duplicate set of rainbows—as if from a Sun 12° below the horizon. The reflection bows, their regular companions, and several supernumerary bows create a rare and awesome spectacle at Eilean Donan Castle, Loch Duich, Scotland, on October 23, 2004.

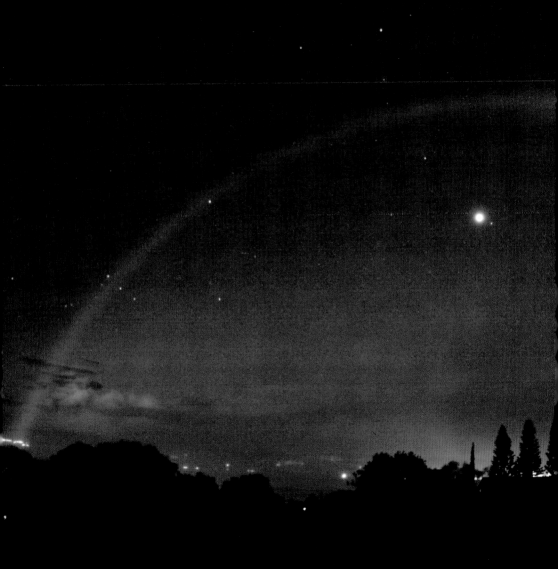

MOONBOW Precision produces a rainbow—but serendipity witnesses it. An exceptionally bright nighttime rainbow in an invisible rain shower vaults the sky opposite the full Moon over Maui, Hawaii, and frames an evening portrait of neighborhood planets on May 4, 2004. Venus is the bright evening star near the center; Mars is above it to the left; and Saturn tops Mars over the bow in this rare, special joint appearance.

PREDICTING RAINBOWS While predicting the momentary and fleeting appearance of a rainbow for any one observer's view is next to impossible (since each person sees his or her own rainbow), we can, however, broadly predict when rainbows are more likely to occur.

Since its bright colors cannot happen without rain, any reliable forecast of stormy or showery weather also includes the possibility of a rainbow. And if the forecast is narrowed to the beginning or ending times of the rainy period, when sunshine and rainfall are more likely to coincide in the sky, the chances of a rainbow appearing increase. Furthermore, if such a time is predicted when the Sun is lower in the sky (40° or less), chasing rainbows becomes a likely adventure.

INTERPRETING RAINBOWS

Rainbow in the eastern sky, tomorrow will be dry;
Rainbow in the west that gleams, rain falls in streams.

According to the Bible, the rainbow is a sign of God's promise that He would never again destroy the world by flood, so its bright-hued appearance is always, first of all, a good reminder after a storm.

Since rainbows appear in rain opposite the Sun, their occurrence gives us an indication of the immediate future. In the Northern Hemisphere, where our weather systems generally move from west to east, a morning rainbow in the west, opposite the eastern Sun, means that a rain cloud is on its way toward us. If the bow appears in the east, it generally means that the storm is ending and fair weather is ahead, now that the Sun has reappeared enough to thrust its light through the remnant of the rainfall.

← **DEWBOW** A tiny rainbow may form in spherical dewdrops or mist when the Sun is low, gracing an orb spider's web, or projected horizontally on the ground as a wide-open hyperbola arching away from the observer. Conducive surfaces include grass, heather, other small plants, spider webs, mists, or light surface fogs. In the few minutes while the Sun was high enough and before the dew evaporated on August 29, 2005, Richard Fleet discovered this small fragment in Pewsey Vale, Wiltshire, England.

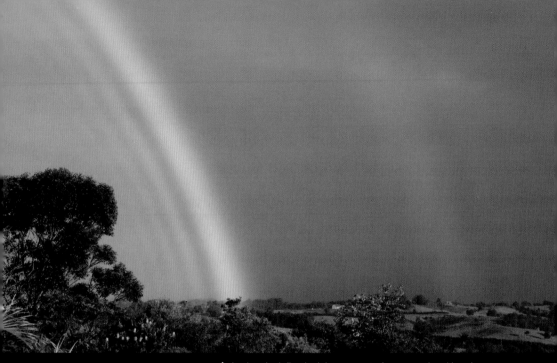

↑ In sharply defined rainbows, a set of narrow colored bands can often be found repeating on the inside of the primary bow, and occasionally on the outside of the secondary bow. Called supernumerary bows, they add an extra-special dimension to the display and are produced by diffraction as light waves cross each other exiting the raindrops.

In an unusual winter morning's shower of extremely fine mist, a spectacular primary bow exhibits four sets of supernumeraries while the secondary bow reverberates with a faint set of its own to its outer (right) edge, as seen at Wollongbar on the New South Wales North Coast of Australia on July 20, 2006.

← The colorfully picturesque phenomena create a brief but wonderfully variegated sky over the confluence of the Pelly and Yukon Rivers at Fort Selkirk, Yukon.

center, in contrast to the corona's bright center. In construction, it more resembles the supernumerary bows as a product of refraction, reflection, and diffraction.

As the sunlight enters one side of the drop, it is first refracted, then reflected off the back of the drop. Much of this light refracts again as it exits the other side of the drop, just as it does to form the rainbow. The greatest bending this process can deliver, however, is 166°—short of what's required to see the glory where it appears: 180° from the Sun. To deflect the additional amount and produce the glorified ring, the rest of the light exiting the drop flows along the inside surface curvature in what is called a surface wave, diffracts from the edge of the drop, and disperses. Light diffracting from all edges of the drop collectively produces a ring; and the larger the drop, the smaller the pattern. Droplets greater than .05 mm, however, do not exhibit this behavior. Hence, the glory can be produced only when the cloud droplets are less than .05 mm.

When the shadow of an observer is cast from a mountain peak onto a lower mist or cloud bank, it appears larger than it would have had it reached the ground. The sight of it on the gauzy vapor is apparently spooky enough to generate some imaginative tales, especially when a glory appears around the head of the shadow. This eerie variation is called the Brocken spectre, and the glow about the head is the Brocken bow, named after the Brocken peak in Germany's Harz Mountains where more than one hiker has either suddenly been spooked by the large figure keeping strides with him, or, alternatively, felt God's special anointing by the appearance of a personal halo.

When the Sun is low in the sky, this same sequence can produce a diffuse white ring around the head of the observer's shadow on a grassy surface containing spherical dew droplets, resembling the blessing of an angelic halo. This effect is called the *heiligenschein*—"holy light"—and is remarkably similar in appearance to the vertical halos of the saints in classical religious paintings.

IRIDESCENCE

The same diffraction effect that brings us the organized rings of the corona also splashes seemingly random splotches of bright iridescence on clouds, which may be located some distance away from the Sun or Moon. Pastel patches of pinks, greens, and blues may be arranged in smudges or orderly bands, especially at the clouds' edges.

Lens-shaped clouds, called lenticularis, often display especially vibrant iridescence. Elongated and polished by the wind into their distinctive shape with well-defined boundaries, they may originate with thin clouds of cirrocumulus, altocumulus, or stratocumulus, whose uniformly sized droplets diffract and disperse the light well. Lenticularis often form in hilly or mountainous regions where the flow of air rises and falls parallel to the terrain, and clouds condense in the crest of the waves.

Nacreous clouds are stratospheric clouds, and at fifteen to twenty miles high, are far above all other weather-related clouds. They resemble cirrus or lenticularis and also show a marked irisation, similar to mother-of-pearl. Their most brilliant colors display when the Sun is several degrees below the horizon.

GLORY The glory phenomenon involves refraction, reflection, and diffraction in which light is bent through 180° in a complex pattern. A portion of the light ultimately disperses from all edges of the drop in the constructive and destructive wave-interference pattern of diffraction, producing the rings. The effect is most often noticed surrounding the shadow of an airplane on a cloud bank below, like this one descending for a landing the morning of November 21, 2004. Pete White, the photographer, reports: "I was the lead pilot for Wyoming Life Flight and we were on the way to Lander, Wyoming, to pick up a patient. There was a thin cloud layer below for the whole trip that ended right over the town. As we descended I noticed the phenomenon 'leading' us and recognized an opportunity about to present itself. A very slight turn to the right centered us and this photo was the result."

← **BROCKEN SPECTRE** Low clouds on Hopegill Head in Lake District National Park, England, catch the photographer's shadow forming the distinctive Brocken spectre surrounded by a glory on February 4, 2006.

97

PREDICTING GLORIES Because it requires being above the clouds or a fogbank, the observation of a glory often says as much about the observer's position as the weather conditions. With widespread modern air travel, many people have the opportunity to witness a glory on clouds below them. When viewed from above, all the middle- to low-layered clouds, (altostratus, nimbostratus, stratocumulus, and stratus) as well as altocumulus and fog, may appear smooth and undulated or fleecy, and produce a glory in your presence.

Such layered clouds are formed when stable air gradually ascends over a cooler layer of air, or over a gentle incline of the land. As it does, the air expands and cools, and condensation permeates the entire layer. This process is generally associated with lower-pressure storm centers and the boundary zones between cold and warm air masses. Tracking the formation of these systems is a good indicator of the formation of future glories.

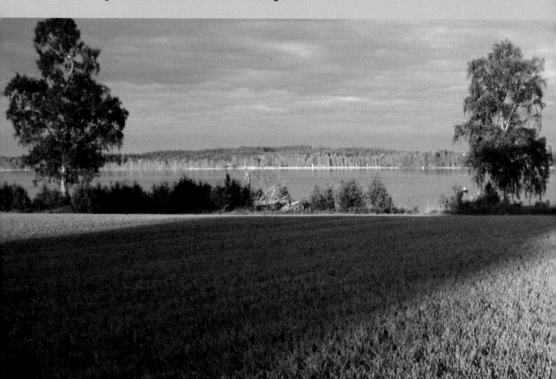

INTERPRETING GLORIES The glory's appearance says much the same as that of the corona: that there is a layer of moisture with uniformly sized cloud droplets. If it is associated with a warm front, and it continues to lower and thicken, seeing your own exalted glory may precede a fall—of rain, that is.

↓ **HEILIGENSCHEIN** In this angelic moment, the *heiligenschein* appears about the head of the photographer—more precisely the aperture of the camera—in the dew on young oats on a sunny spring morning.

IRIDESCENCE Observed from an altitude of 8,200 feet atop Pic de L'Orri in the Pyrenees mountains, the uniformly small droplets of the passing clouds are awash in glowing pastels from diffraction iridescence.

→ Pretty pastels paint the sky as nacreous clouds iridesce in the twilight over Turku, Finland, on January 16, 1997.

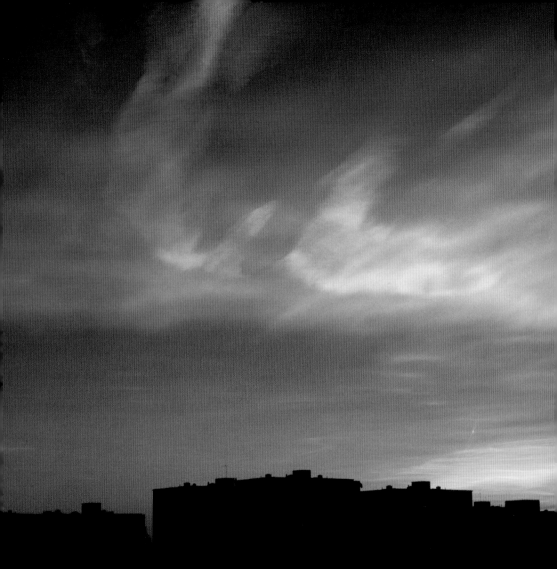

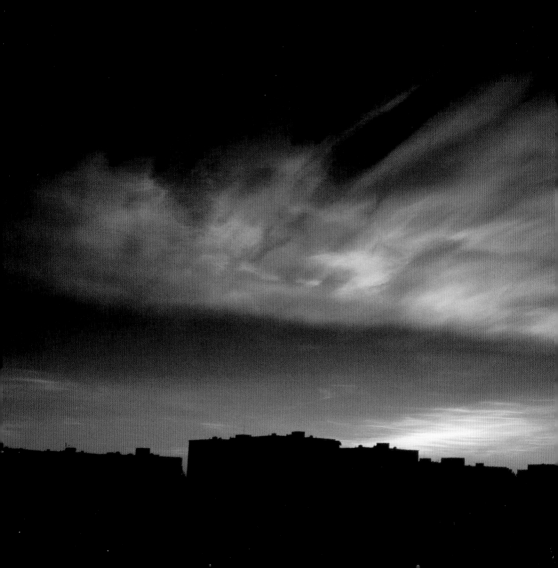

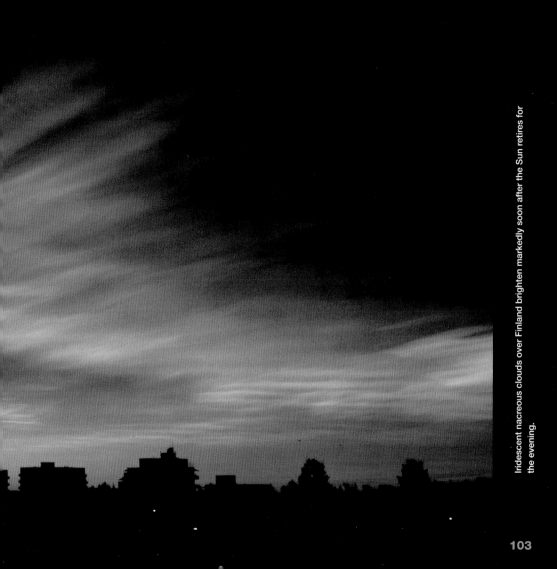

Iridescent nacreous clouds over Finland brighten markedly soon after the Sun retires for the evening.

NIGHT-SHINING CLOUDS Still higher, rarer, and more mysterious than nacreous clouds are noctilucent clouds that resemble thin, silvery cirrus in the summer nighttime sky. At an altitude of about fifty miles, and observed only from high latitudes, they become visible after twilight at about the same time as first-magnitude stars. Although their coloration varies, it is due to the reflection of sunlight from far below the horizon, and not to iridescence. Gray at first appearance, they brighten to electric blue, silver, and sometimes red, gold, and white, before fading again to gray by dawn. The Upper Atmosphere Research Satellite (UARS) has confirmed that they are composed of ice condensed on very fine dust, which may or may not be extraterrestrial in origin.

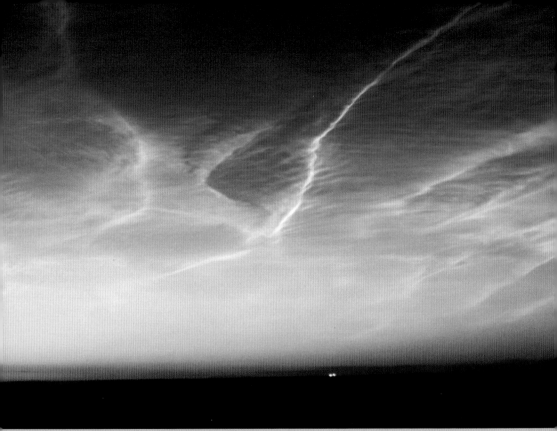

↑ Noctilucent clouds spangle a July night over southwest Finland. Such high-flying clouds have recently been renamed Polar Mesospheric Clouds.

They are rare and poorly understood, but because they diffract colors in irregular patterns, they are probably composed of minute water droplets and/or spherical ice particles.

INVESTIGATING POLARIZED RAINBOWS

Whenever light is scattered or reflected, it becomes polarized (see Chapter 1); because the sky is most polarized at 90° from the Sun—which is exactly where the rainbow forms—and because rainbows involve reflections, those colored arcs are strongly polarized.

Due to the angle at which the light strikes the back surface of the drop, almost all the reflected light is polarized perpendicularly to its incoming direction. And because seeing that light from each contributing drop is determined by the relationships between the Sun, the drop, and the observer, the rainbow is polarized tangentially to its arc. Light vibrating horizontally at the top edge of the bow is much more intense than the light vibrating vertically across the bow.

Use a pair of polarized sunglasses to observe a rainbow. Because they limit the amount of light that passes through them to only those rays that match its vertical orientation, the top of the arc will appear to be missing, while the vertical sides will be more highly contrasted. Tilt your head sideways as the sunglasses continue to filter those tangential rays along the arc, and the missing sector will move along with your head's orientation.

Only about 4.5 percent of the Sun's light in the sky reaches our eyes in the primary bow, and of that, nearly 96 percent is polarized perpendicularly. Just 2 percent contributes to the secondary bow, which is 90 percent polarized. The concentrated light inside the rainbow cone—and outside the secondary bow—is also polarized tangentially to a lesser degree, as it has the same origin as the bows. Rotating a camera's polarizing filter can make the rainbows vanish from sight (although they still exist!) as the observed skyscape dims to the level of the absence of light in Alexander's Dark Band.

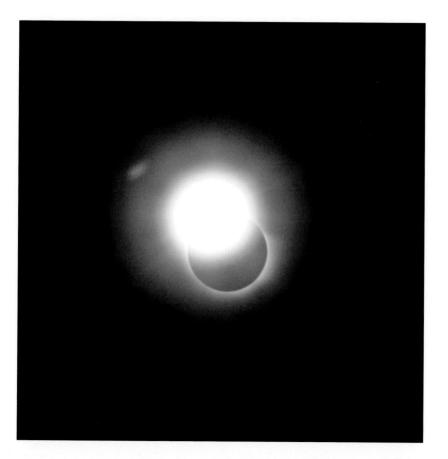

107

Crowning Radiances
Halos, Arcs, and Company

UPPER TANGENT ARCS AND COMPANY Luminous arcs stack and shimmer near Davos, Switzerland, on December 20, 2005. From bottom to top, centered on the Sun at 12° elevation: the 22° halo, the gull-winged upper tangent arc, the supralateral arc, all topped by a circumzenithal arc. Appearing inside the 22° halo is a vertical sun pillar, which ends with a faint and very rare v-shaped Moilanen arc, and a portion of the horizontal parhelic circle. Parhelia brighten the sides of the 22° halo. Also easily noticeable in this portrait is the relative dark halo interior compared to the brighter but decreasing intensity of its outer edge.

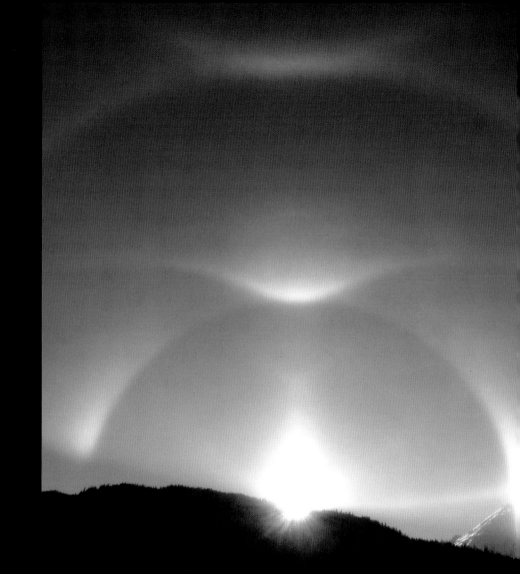

High above the multicolored realm of water-borne images reigns an elite class of frosted diadems dispersing light to the masses. In resplendent circlets festooned with light and adorned in lustrous crystal geometry, the extended family of halos, arcs, and other luminaries serves as a radiant crownpiece to a spectacular sky.

The high distinction of halos comes from their creation in illuminated ice crystal clouds or a sky filled with falling ice crystals. Their dynasty includes a variety of colored or pearly rings, or arcs about the Sun or Moon, whose banner colors result from refraction through the crystals. Adjacent or opposing crystal faces form tiny prisms to disperse the penetrating light in its component colors; luminous white images result from reflections from crystal faces. Small, randomly oriented crystals produce the circular crowns of light; larger crystals settle aerodynamically into specific orientations as they fall to form a coterie of attractive arcs making appearances with or without a halo consort.

Ice crystals occur naturally in many configurations, but just two basic structures are responsible for the wide realm of halos. Crystallized into hexagonal plates or columns—whose ends may be plain, pyramidal, truncated, or hollow—and with varying diameters, orientations, and motions—these ice crystals serve as many tiny prisms and reflectors for the available light. Add the full range of solar elevation and angles of sunlight lancing through them, and ice in the atmosphere provides a ponderous wealth of pastel-hued possibilities.

22° HALO

The most common halo is produced as light refracts through one crystal face and out another, in an effective prism of 60°. In such a prism, the light is deviated a minimum of about 22°, varying slightly according to wavelength, to create a ring of color about 22° from the Sun or Moon, with red on the inside. Some rays bend at greater angles and account for the fading, outward edge of the halo extending up to 50°. No light is bent less than 22°, which creates the halo's dark center. Despite its frequency, the actual crystal shapes involved and their tilts and orientation, are still uncertain. In order to fashion a full halo, it may be that the sky is filled with large, imperfect columns tilting with large variations about their equilibrium positions, and falling with random orientations.

46° HALO

A huge halo of a 46° radius about the Sun or Moon is formed as light refracts into a crystal through a prism face and out through a basal face, forming an effective 90° prism, and deviating 46°. It is quite faint, rare, and even more rarely complete, with its colors spread about three times as wide as those of the most common variety. Like the 22° halo, randomly oriented hexagonal crystals are required, whose diameters range from between .015 to .025 mm, and which are found at temperatures below approximately 5°F (-15°C). The longer the crystal columns, the fainter the halo becomes.

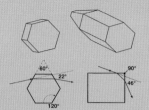

ICE CRYSTAL GEOMETRY

Ice crystals that produce the most common halos and arcs are hexagonal in cross section, and their opposing or adjacent faces create the angles of effective 60° and 90° prisms. A crystal is called a column if its principal axis is longer than its diameter, and a plate if it is much shorter. Columns capped with a pyramid on one or both ends, which may be pointed or truncated, may have up to twenty faces and eighteen different pathways on which light can travel on its way through the crystal.

The 22° halo is produced as light deviates 22° through an effective 60° prism. The 46° halo is produced as light deviates 46° through an effective 90° prism between a column's prism and basal faces. Angles between pyramidal crystal faces can vary from 28° to over 80°, deviating light from 9° to 35°, and producing other sizes of circular halos.

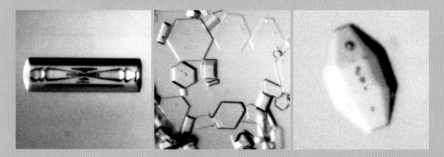

BASIC ICE CRYSTAL SHAPES These crystals, shown here in microscopic photography at the South Pole, Antarctica, demonstrate the variety of shapes. Left: Columns have one axis much longer than the other. Center: Plates have a much shorter principal axis. Right: Pyramidal crystal faces taper to a point. Note also that there may be hollow spaces within the crystals, which also affect the pathways of light passing through them.

Other variations of crystal shape, length, width, diameter, orientation, and incident angles of light, with multiple combinations of refractions and internal and external reflections, produce a multitude of luminous streaks and spots.

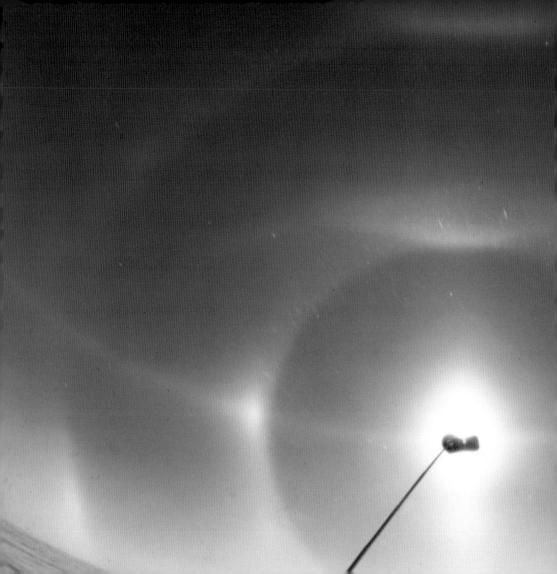

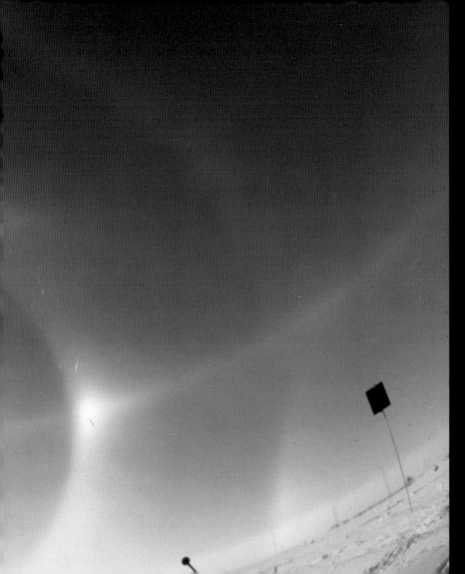

KALEIDOSCOPE SKY Sunlight spangles the south polar sky in a fascinating geometric exhibition on January 11, 1999. Ice crystal plates and columns redirect light from the 22° elevation of the Sun into a myriad of luminous halos, arcs, circles, spots, and sky-tracers. The extremely rare, hour-long, world-record display exhibited twenty-two different halo forms simultaneously. Seen in this view, from top to bottom: circumzenithal arc, supralateral arc, concave Parry arc, upper tangent arcs, 22° halo, parhelic circle, parhelia, and infralateral arcs.

113

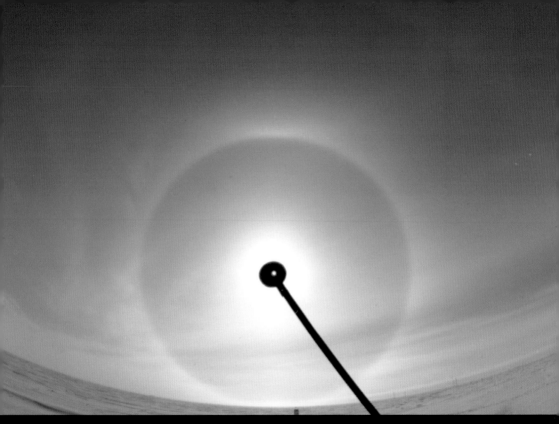

CIRROSTRATUS WITH HALOS A uniform layer of ice crystals in a deck of cirrostratus creates an ideal roost for halos; watch for their appearances whenever the high clouds visit. The 22° halo is too large to fit in the field of view of standard 35–50mm camera lenses. This view includes a rare glimpse of the 46° halo and was taken with a 16mm lens.

A bull's-eye in the sky is the insignia of pyramidal ice crystals spraying light in variously sized, odd radii halos over Vaala, Finland. Analysis of the white rings by the photographer and halo scientist Jarmo Moilanen reveals:

A: Full 9° halo; B: Lower 9° plate arc (also known as lower 9° parhelion); C: Faint but almost full 18° halo; D: 18° plate arcs (a.k.a. 18° parhelia) as broader segments on both sides of 18° halo; E: Faint 20° halo; F: This broad halo is a probable combination of 22°, 23°, and 24° halos; G: This broad segment on top of a 22° halo is an upper 23° plate arc (a.k.a. upper 23° parhelion); H: Bright spots on sides are lower 24° plate arcs (a.k.a. lower 24° parhelia); I: Faint 35° halo Randomly oriented crystals with pyramids on both ends and a middle prism formed this rare display on May 12, 2002.

OTHER CIRCULAR HALOS

Although rare, halos with radii of 9°, 18°, 20°, 23°, 24°, 35°, and others have been observed and explained by refraction through pyramidal crystals that tend to be less uniformly oriented as they fall. Because it is so close to the Sun, the 9° halo may occur more often than observed.

PARHELIC CIRCLE

A faint white circle passing through the Sun and running parallel to the horizon for as much as 360° is the parhelic circle. It is caused by reflection off the faces of vertically oriented hexagonal crystals. Its nighttime counterpart, the paraselenic circle, passes through the Moon. The subparhelic circle occurs as far below the horizon as the Sun is above it, as light deflects a total of 180° by refracting into the top of a horizontal column, reflecting twice internally off its adjacent corner faces, and refracting once again as it passes out parallel to its incoming direction.

PARHELIA, PARANTHELIA, AND ANTHELION

Associated with the parhelic circle, but often observed without it, the parhelion, also called the sun dog or mock sun, is a colored, luminous spot on either or both sides of the Sun and at the same elevation as the Sun. The coloration is typically limited to a little bit of red tint on the inner edge. Parhelia form from refraction through a 60° prism in hexagonal plates falling with their long axes vertical, and may occur at several positions along the parhelic circle, at about 22°, 46°, and others; as the solar elevation increases, the angular positions widen slightly. Paranthelia refer to parhelia occurring at a distance of 120°, and oc-

CHARACTER-BUILDING NAMES Many of the halo phenomena have descriptive names that have been built with modular units of Latin and Greek words. Knowing the meaning of these root phrases may help you understand their characters—and their locations. Example: The paranthelion is found near the opposite point of the Sun.

ant: opposite (Greek)
circum: around (Latin)
helio: Sun (Greek)
infra: beneath or below (Latin)
par: equal or alongside (Latin)
selene: Moon (Greek)
sub: underneath (Latin)
supra: above or beyond (Latin)

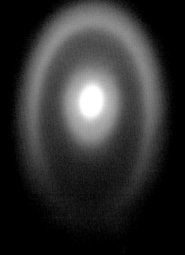

RARE ELLIPTICAL HALO On extremely rare occasions, a mysterious but unmistakable elliptical halo appears about the Sun or Moon. Halo researchers remain stumped over its exact formation, although computer simulations modeling very thin platelike crystals with double, gently sloping pyramidal faces (akin to a convex lens) have approximated its shape, as well as the relative brightness of its lower portion.

Guillaume Poulin reports that he was struggling to get his car started on December 8, 2005, in the 5° F (-15° C) night when he noticed the apparition surrounding the first-quarter Moon and ran for his camera. Although the sky was clear to the south and east, the air from the northwest, rising over nearby Mont-Mégantic in southern Quebec, produced the icy shroud that in turn produced the rare spectacle. The apparition lasted for about fifteen minutes, then appeared only sporadically in the passing clouds. A reddish inner border is clearly seen, and another unexplained small halo draws a very tight loop around the Moon. A tiny green lens flare smudges the bottom right edge. Poulin took several photos—with varied exposures and magnification—with his digital camera, including one in which the stars were visible, to be able to more accurately measure the size of the phenomenon. His car did ultimately start.

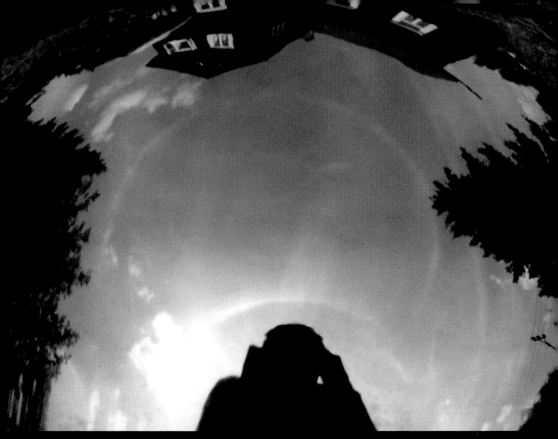

SKY CIRCLE In a fish-eye view of the entire sky imaged in a metal reflector, a complete parhelic circle formed by ice crystal columns etches its mark in the dome over the Jizera mountains in the Czech Republic, on August 17, 1998. A very bright, circumscribed halo surrounds both the Sun and the photographer's head.

→ **SKY LINE** A segment of the white parhelic circle stands out among the cirrus, and bulges with the bright spot of the 120° paranthelion over Uffington White Horse in Oxfordshire, England, on August 8, 1993. Despite the fact that hundreds of people live in the area, very few witnessed this rare spectacle—a reminder to keep looking up!

LOCATING MAJOR HALOS AND ARCS The most common halos occur in the vicinity of the Sun and are portrayed here in a view straight upward to the observer's zenith, showing relative positions. Many arcs change lengths and convexity or concavity according to the Sun's elevation, and may appear differently in the sky.

O–Observer	f–46° halo
S–Sun	g–circumzenithal arc
Z–Zenith	h–supralateral arc
a–parhelion	i–suncave Parry arc
b–parhelic circle	j–upper tangent arc
c–paranthelion	k–sun pillar
d–anthelion	l–lower tangent arc
e–22° halo	m–infralateral arc

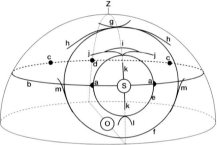

casionally at 90° or 140°, from the Sun, and are formed from at least two internal reflections. The anthelion, also called the countersun, is a luminous spot on the parhelic circle 180° away from the Sun. The brightness of this spot is thought to be the superposition of the parhelic circle and the anthelic arcs, and as such, is essentially a reflective act.

When these same effects occur in moonlight, they are generally weaker due to the lesser luminosity of the Moon, and are known, correspondingly, as paraselenae or mock moons, parantiselenae, and antiselene. Parhelia and paraselenae are sometimes connected to the 22° halo by the obliquely oriented Lowitz arcs.

SUN PILLAR

When hexagonal plates fall and wobble horizontally like falling leaves, and the Sun is low in the sky, sunlight may reflect off the tilting basal faces, producing a column of white light above or below the Sun called the sun pillar. Light reflected downward toward our eyes from the lower faces of tilted crystals form upper pillars; those reflecting upward from the top face of the plate form lower pillars. Sun pillars may also form from horizontally oriented columns that rotate about their horizontal axes as they fall. Also called light pillars, they are most frequently observed near sunrise or sunset, and may extend 5° to 10° to as much

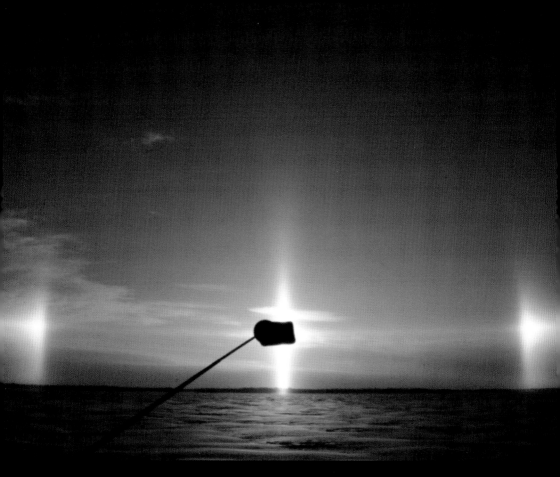

SUN DOG A close-up of the colorful spot known as the parhelion, sun dog, or mock sun, appears in the icy remains of a thunderstorm's anvil over the Magdelena mountains in New Mexico in the early evening of August 30, 2006.

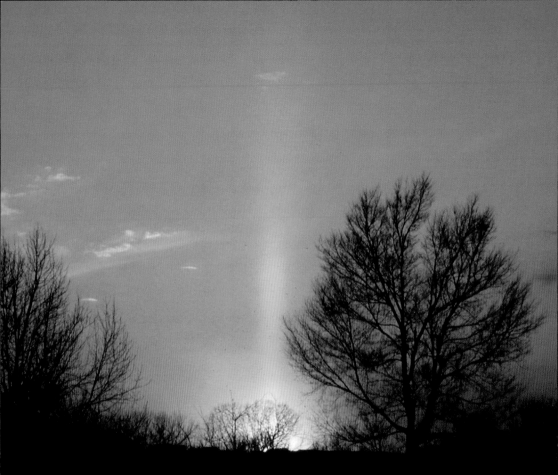

REACHING FOR THE SKY. The sunset flares skyward in suburban Des Moines, Iowa, on February 27, 2001, as ice crystal plates lingering in the sky from the previous day's snowfall reflect a column of light upward. Opposite: Brightly signaling the day's end, a golden sun pillar burnishes the western sky over southwest Finland.

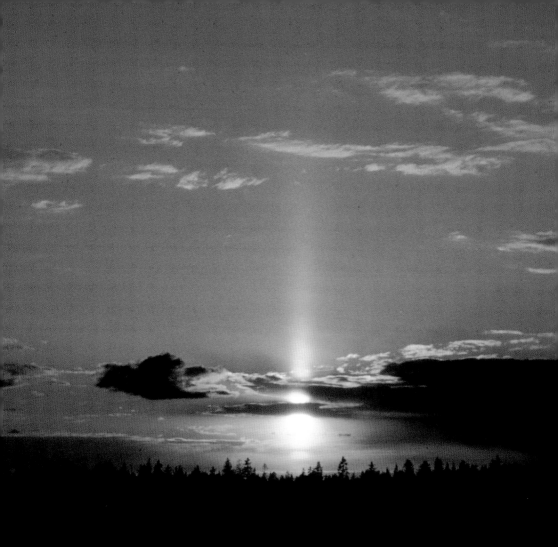

as 20° from the Sun. Since they are formed by reflections instead of refractions, pillars take on the same color as the Sun.

Bands of white light intersecting at right angles over the Sun form a sun cross, which is created by the superposition of a portion of the parhelic circle and a sun pillar.

SUBSUN

Horizontally oriented plates form the variously angled mock suns as light refracts through the prism faces. When light reflects off the top basal faces instead, like so many tiny mirrors, the Sun is brilliantly reflected in the subsun. This image can only be viewed from an airplane or a high mountain, since it forms as far below the horizon as the Sun is above it.

TANGENT ARCS

Tangent arcs are the generic term for several types of luminous arcs that form tangent to other halos. The 22° halo may exhibit horizontal and vertical tangent arcs, formed by refraction through hexagonal columns whose principal axes are aligned horizontally. When the crystals oscillate about the horizontal axis, larger arcs are produced. When the solar elevation is greater than about 30°, the upper and lower tangent arcs merge, and form the circumscribed halo.

CIRCUMSCRIBED HALO

When the solar elevation is greater than about 30°, the upper and lower tangent arcs of the 22° halo merge, and form a kidney-shaped luminous curve circumscribed about the halo, which may or may not be present. The arcs shift to form an ellipse as the solar elevation increases to about 45°, and at a solar elevation of 55°, they are so close to the 22° halo, they are practically indistinguishable from it. The circumscribed halo is formed by refraction through ice columns suspended horizontally.

INFRALATERAL AND SUPRALATERAL TANGENT ARCS

Infralateral tangent arcs, a rare pair of oblique and brightly colored arcs, convex toward the Sun and tangent to the 46° halo, are produced by refraction through an effective 90° prism in hexagonal ice columns whose principal axes are horizontal, but otherwise randomly directed. They occur at points below the Sun's elevation. The supralateral tangent arcs are a complementary pair that form above the solar elevation, but only when the Sun is below about 22°. Both are clearly visible on the South Pole display photo shown on pages 112-113.

LOWITZ ARCS

A type of tangent arcs, the Lowitz arcs are luminous curves of pale colors that extend obliquely downward from the 22° parhelia or paraselenae on either side of the Sun or Moon. They are concave

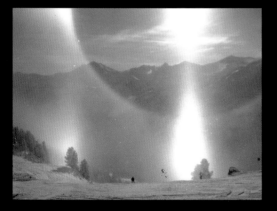

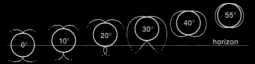

↑ LOWER TANGENT ARCS AND GUESTS
The Alyeska Ski Resort near Girdwood, Alaska, hosts this spectacular display of lower tangent arcs through pyramidal ice crystal columns floating horizontally in a thick ice fog layer. With the Sun low in the sky at just 6° elevation, the subsun and a lower sun pillar make their appearances inside a portion of the 22° halo, their brilliance possibly enhanced by reflection from water or ice of the Turnagain Arm of Cook Inlet deep in the valley.

↖ CRYSTAL FOLLIES A brilliant matinee of ice crystal follies treated the skiers at the Obertauern ski resort in Austria on December 15, 2005. A sharp, red-rimmed 22° halo slices a huge arc through the downslope view while exceptionally bright parhelia, subparhelia, sun pillar, and subsun demand attention.

← THE TANGENT TANGO Variations of the tangent arcs gambol with respect to the 22° halo and the solar elevation.

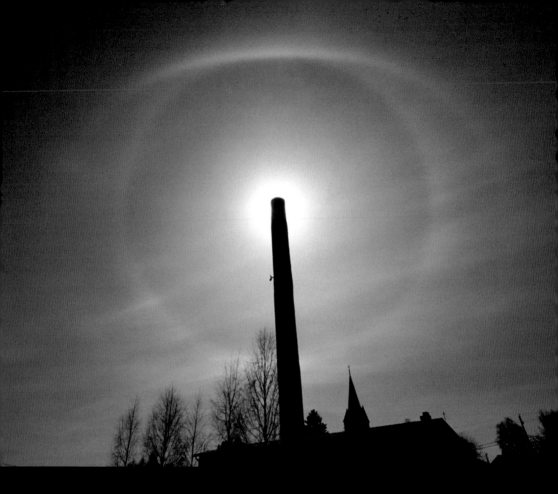

CIRCUMSCRIBED HALO, SOLAR ELEVATION OF 38° A chimney shields the Sun's glare as a circumscribed halo, formed by the extensions of both the upper and lower tangent arcs, encases a 22° halo over Juva, Finland, on April 26, 1994.

toward the Sun, and their inner edges are tinted red. Named after Tobias Lowitz, who first observed and described them in St. Petersburg in 1790, they were a source of controversy among scientists for a long time because of the lack of other reliable observations or photos. They are now documented and confirmed, but their formation continues to be disputed. One theory posits that they are formed by refraction through effective 60° prisms of columns and/or plates, as their vertically oriented axes tilt back and forth as they fall (in the so-called Lowitz orientation). This phenomenon is rare and can only be seen when the Sun's elevation is high.

PARRY ARCS

First described by William Parry in his search for the Northwest Passage in 1820 from the Canadian arctic, a whole family of faint but colorful arcs and swirls are produced by refraction and internal reflection through horizontally oriented columns, with two faces vertical and two faces horizontal. Such so-called Parry orientation of crystals forms a variety of tangent sunvex (convex to the Sun) and suncave (concave to the Sun) elliptical arcs. Parry arcs to the 22° halo are rare, faintly colored arcs above and below the Sun. Tangent to the 46° halo, Parry lateral and Parry supralateral arcs are boomerang-shaped arcs that form wholly within the lateral and infralateral arcs. Upper and lower anthelic arcs form 180° away from the Sun, just above and below the parhelic circle. Parry-oriented crystal columns, with two vertical faces and two horizontal faces, are responsible for a variety of large and small arcs, loops, and swirls; others in the Parry-oriented family include the rare Tricker arcs, Hastings arcs, helic arcs, antisolar arcs, and subhelic arcs.

CIRCUMHORIZONTAL ARCS

When the Sun is higher than 58° above the horizon, a circumhorizontal arc may form 46° below the Sun, parallel to the horizon, extending for about 90° of arc. Red on its upper margin, and as bright as the circumzenithal arc, it is produced as light shines through 90° prism plates or Parry-oriented columns, refracting through a vertical plate face and out through a horizontal face.

The striking specimen displayed on the jacket of this book commanded about a half hour's worth of eyewitness attention on June 3, 2006 over northern Idaho with the Sun 63° high. From a dock on Hauser Lake near Post Falls, Brian Plonka watched the vibrant circumhorizontal arc unfold due south as fall streaks of cirrus in the right place at the right time flushed a vivid and full-toned fiery spectrum about 46° wide. Low-level cumulus dress the skyscape while a jet heading due west sketches a short contrail; a pale camera lens flare spots the top.

AND COMPANY . . .

Many other variations of ice crystal optics are possible; most are quite rare, but real enough and often intriguingly complex. Some arcs overlap, or form within other arcs, or display poorly, making observation and identification difficult. About sixty different halo forms have been photographed; some are fully

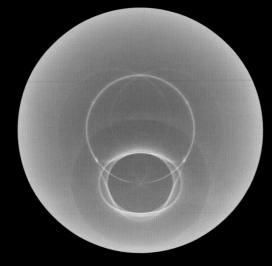

ST. PETERSBURG DISPLAY, JUNE 18, 1790 Tobias Lowitz was fortunately in the right place at the right time to witness a once-in-a-lifetime crystal outburst that lasted from 7:30 a.m. to the afternoon. This computer simulation depicts the display's peak at about 10 a.m. when the Sun was 51° high in a zenith-centered view. Shining down on him that day were a circumscribed halo, a faint 22° halo, a relatively bright 46° halo, a pair of infralateral arcs, the parhelic circle, a pair of parhelia, a pair of paranthelia at 120°, the anthelion, a pair of faint Wagener arcs arching from the top of the 22° halo to the anthelion, and of course the controversial Lowitz arcs extending from the parhelia to the 22° halo. This graphic was created using HaloSim, a free software program that simulates the entire range of observable halos and arcs. HaloSim www. atoptics.co.uk/atoptics/phenom.htm © L. Cowley and M. Schroeder. All rights reserved.

→ A unique and exciting outdoor classroom opened up to the students of Särkijärvi School near Muonio in northern Finland (68° N), on October 26, 2006. Not only did the usual cohorts of a spectacular diamond-dust display turn out—(top) parhelic circle, parhelia, Lowitz arcs, and a 22° halo, topped with the double chevron of an upper tangent arc and a sunvex Parry arc—but also (bottom) the stunning and never-before-photographed 46° contact arcs showing as series of three distinct arcs immediately below the circumzenithal arc. While it had been predicted theoretically, no convincing photographic evidence existed until now—a clear example of the important contributions amateur observers with cameras can make to atmospheric science. Other components of the stunning display, not shown in these photos, are the rare helic arc and diffuse anthelic arc. The diamond dust in the otherwise clear sky may have originated from snow-making machines at a ski slope a few miles away.

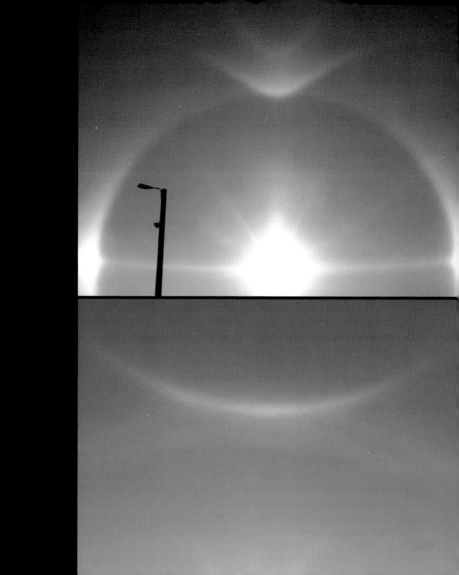

understood and documented, while the causes of others have yet to be satisfactorily explained. Still others have been only theoretically predicted, and not observed in nature.

Yet of all the thrilling and spectacular sights of the sky, the prodigious and awe-inspiring halos and their dazzling kin are produced from just a tiny fraction of a percent of the light that reaches Earth. Combine that with the critical abundance, type, and orientation of ice crystals at different levels and the constant variation of the Sun's position—not to mention being in the right place at the right time—and it's a wonder we see and enjoy their crowning radiances at all.

OBSERVING HALOS

Halos make more appearances than rainbows do, but many people miss their awesome artistry simply because they do not look up. You've heard about the importance of stopping to smell the roses, well—pause and see the sky! Look up and look often.

Halos happen when ice crystals abound in the air. This condition may be visible in simple streaks of cirrus or thick banks of cirrostratus, or quite invisible in a sparse veil. In addition, the Sun must be shining through them at such angles as to fling its light and spangle the sky. While this can happen at any time, we are more apt to see halos and their kin when the Sun is higher in the sky, both daily and seasonally. The full or gibbous Moon also creates its own halo gallery in similar conditions, so keep an eye out for its nighttime exhibitions as well.

To see solar halos well, you must first block the Sun's glare with your hand or another object. While your hand is in the air, you can also get a handle (so to speak) on the caliber of the event by stretching out your arm, placing your thumb over the Sun, and spreading your fingers to span 20° to 25° of angular measurement. If the halo under scrutiny is the most common one at 22°, you've nailed it at your fingertips. (See Chapter 1 for other "handy" measures.)

If you see one halo, there could be others. Scan the entire sky, including behind you, to discover if there are any other accompanying arcs, circles, or spots.

The German Halo Research Team documented the relative frequencies of halo sightings from ten years of observations. In Europe a 22° halo is observed on average about one hundred days per year; parhelia about seventy-three days per year; tangent arcs about twenty-seven days per year; and a 46° halo about four times per year.

PREDICTING HALOS

Because the Sun and ice crystals are a team act, whenever they appear together in the sky, there's the possibility for an impromptu exhibition. Anticipating their concurrent arrivals, however, calls for a sneak preview of other coming attractions.

Clouds that form near the top of the troposphere are composed entirely of very small ice crystals. White and delicate in appearance, individual cirrus may take the form of strands or filaments, or of hooks

CIRCUMZENITHAL ARC Like a sky-high Cheshire cat, a brilliantly colored grin graces the blue expanse over Caledon, Ontario. A vibrantly colored arc of about 90° in length, red on the outside, violet on the inside, and centered on the zenith, the circumzenithal arc is found about 46° above the Sun. It occurs only when the solar elevation is under about 32°, and is usually very short-lived as light refracts through plates or Parry-oriented columns in a 90° prism, entering through a top horizontal face and out through a vertical face. The extremely rare Kern arc may join the circumzenithal arc to form a circle.

CIRCUMHORIZONTAL ARC A spectacular circumhorizontal arc over Spokane, Washington, flaunts its flashiness for about two hours on June 2, 2006. The bright, broad arc parallels the horizon and forms in ice crystal plates and columns when the Sun is higher than 58° in the sky. The close-up (right) shows the sumptuous purity of its colors in the translucent cirrostratus.

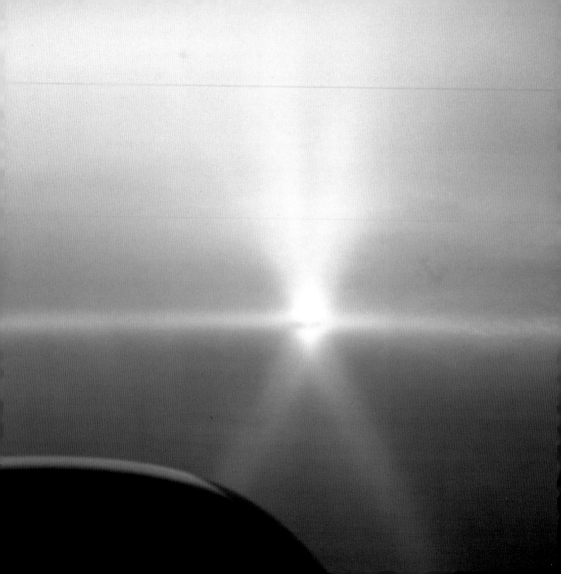

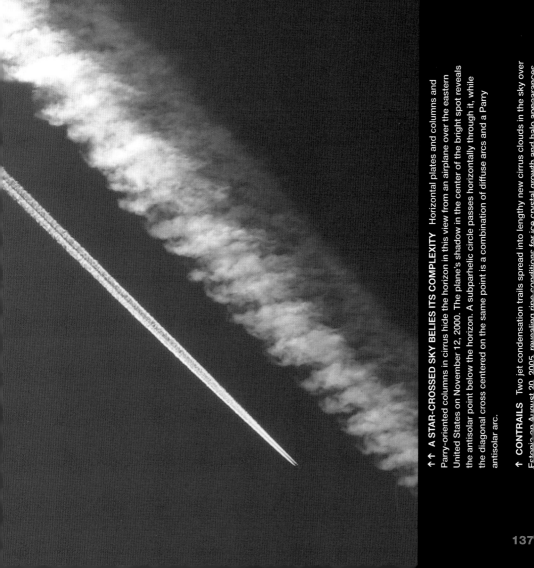

↑↑ **A STAR-CROSSED SKY BELIES ITS COMPLEXITY** Horizontal plates and columns and Parry-oriented columns in cirrus hide the horizon in this view from an airplane over the eastern United States on November 12, 2000. The plane's shadow in the center of the bright spot reveals the antisolar point below the horizon. A subparhelic circle passes horizontally through it, while the diagonal cross centered on the same point is a combination of diffuse arcs and a Parry antisolar arc.

↑ **CONTRAILS** Two jet condensation trails spread into lengthy new cirrus clouds in the sky over Estonia on August 20, 2005, revealing ripe conditions for ice crystal growth and halo appearances.

CUMULONIMBUS ANVIL The Sun illuminates the frozen top of a cumulonimbus on July 7, 2005, as seen from three miles high near Barcelona, Spain. The anvil-shaped presence reveals that conditions are ripe for both ice crystal formation and halos. As this storm grew to a height of about five-and-a-half miles, it also produced hail.

when the crystals grow large enough to fall out of the cloud as dark, vertical streaks, known as fallstreaks. These fallstreaks are usually curved or slanted, shaped by changes in the horizontal wind, and popularly known as mares' tails. (Note those in the cover photo of the circumhorizontal arc.) Cirrostratus is a uniform layer of ice crystals, which may be very thin and transparent or thick and translucent.

Another variety of ice crystal cloud is the cirrocumulus, which takes on the appearance of small, rolled tufts in characteristic ripples that reminded old-time mariners of fish scales. Their proverb "Mackerel sky and mares' tails / Make lofty ships carry low sails" is perceptive in that cirrocumulus and cirrus are associated with the approach of a warm front and may precede thunderstorms. While they don't give much notice, the ice-laden cirriform clouds are the best indicators of the possibility of a halo.

Another telltale sign of the presence of ice crystals—and therefore of possible halo happenings—is the appearance of jet contrails that streak and stay in the sky long after the plane is out of view. Condensation trails form from the water in the aircraft's exhaust and usually quickly evaporate, but those trails that quickly freeze instead (at -40°F or lower) linger awhile. If the air at that level is conducive to crystal growth, the contrails may be stretched by the wind into extensive sheets of new cirrus—and embedded halos.

Yet another source of ice crystal clouds for halo formation is found at the very top of tall thunderstorms, where strong updrafts have spread horizontally in the cold air, forming the "anvil" of the cumulonimbus. Such cloud tops can be associated with quickly moving cold fronts or form completely apart from frontal systems in rising thermals.

INTERPRETING HALOS

When Sun or Moon is in its house
Likely there will be rain without.

Okay, so it doesn't exactly rhyme, but this old saying is accurate nearly 80 percent of the time. A halo around the Sun or Moon usually brings rain.

Halos and their kin are sure signs of frozen moisture in the air, whether the clouds are visible or not. The high-level cirrus and cirrostratus clouds may be so sheer that the Sun's intensity at the ground is not noticeably diminished, and the day seems perfectly clear. But change is likely on its way. Cirrus clouds are the vanguard of an advancing warm front pushing warmer air over retreating cooler air, usually with rain arriving in twenty-four to seventy-two hours. Old-time farmers depended on such signs for planning their work in the fields, and noted that the longer the storm took to come in, the longer it lasted—a truism based on the speed of the frontal system's forward motion.

Apparitions, Specters, and Phantasmagoria

Mirages and Refractive Deeds

The 164-foot-tall lighthouse of the Isokari Islands in the Baltic Sea shrinks and stretches with the weather conditions, as seen from 8.7 miles away. As an undistorted reference, the center image displays its three red and three white bands of equal height. Look closely to find the image in which seven red bands appear.

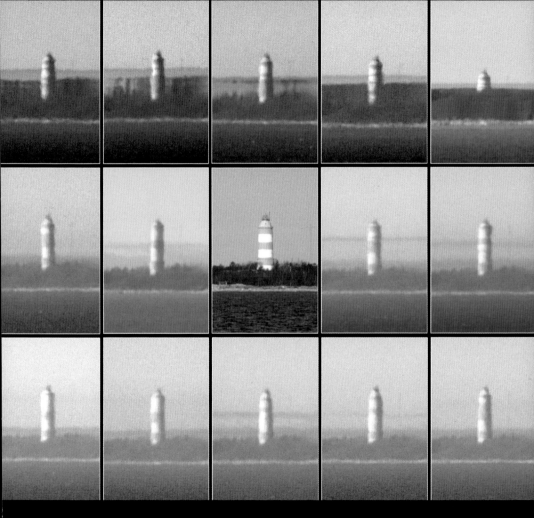

A fantastical mirage distorts the conical Dalrymple Rock island and other promontories near Thule, Greenland, in August 1992. At just 800 miles from the North Pole, the Midnight Sun shines from the middle of April through August, when the sea finally thaws and opens. Clear arctic air, though relatively cool even in summer, remains in sharp contrast to the cold seawater and commonly plays such tricks on the eyes. Ever-changing layers of air with varying densities deviate light waves at extraordinary angles, recasting the usual and accepted visible reality into the freakish and absurd. This fabrication in Baffin Bay consists of many towering, displaced, and inverted effects in complex oversize size layers, as E. M Morgan.

Fantastic sequences of seemingly haphazard imagery may be more often associated with dreams and fevers than a rational mind. Yet the real world is a daily host to such bizarre and perverted phantasmagorical fabrications, rendered in glorious natural Technicolor by the ordinary interaction of visible light with air.

Being both flexible and divisive, as well as the transmitter of all we see, light has seemingly infinite ways of representing all we recognize in ways we may not recognize. Literally, from out of thin air, the full play of its energized rays can conjure up giants, make solid objects vanish, and construct elaborate, otherworldly spectacles in just seconds. Just as quickly, it can flash bright beacons or flutter our focus. On apparent whims of trickery, it may capriciously obliterate a view or miraculously permit the seeing of real objects hundreds of miles away. Will-o'-the-wisp wraiths and almost-recognizable specters arise, tease, and flirt with our rational bearings.

Despite the apparent hokum of the images, however, the amazing transformations of solid objects and surrounding scenery into shifty, elusive, and duplicitous figures are created according to straightforward laws of optical physics, which we are increasingly able to understand, explain, and predict. Performed by the team of light and air, such distortions are the many manifestations of multiplex mirages and other refractive acts.

The mirage is a true thing: a distorted image of real objects caused by light refracting through the air. Because the atmosphere is denser than the vacuum of space, light always refracts to a small degree when it passes through air. But at times, when the vertical temperature profile of the air near the surface (and hence its density) develops sharp differences over short distances, light may bend significantly along its path, distorting what is seen.

The term "mirage" is popularly used for all sorts of distorted images we see when the atmosphere acts as a lens. In simple refractive acts, a single erect image may be distorted vertically and displaced either above or below the actual object. In greater bending operations, at least one part of an image appears inverted. This so-called mirror image is the origin for the French word in use, which means, "to be reflected." But don't get confused, mirages are produced by light refracting or bending—not reflecting—within certain portions of the atmosphere.

SIMPLE REFRACTIVE ACTS

Because we live in an atmosphere that is much denser than the vacuum of space, everything we see is displaced somewhat from its actual location. This is perfectly normal because the light—by which we see anything and everything—bends a bit through refraction as it encounters the denser medium of air and portrays objects slightly above their true positions. This effect is called terrestrial refraction, and most of it is barely noticeable (although surveyors must account for it all the time).

It is when this effect is magnified over large distances or exaggerated through sharply different densities of air (which change continuously with altitude), that very interesting images can occur.

MIRAGE VS. ILLUSION A mirage is a physical reality in which light refracts through the air, bending and distorting visible objects. It can be photographed.

An illusion is an erroneous perception of reality in which the mind is bent and distorted into believing something false. It cannot be photographed.

HIGHWAY WATER MIRAGE One of the most common mirages is the seeming appearance of water on a highway as light from the sky is bent low on its way to our eyes. In this view, the dark asphalt of the recently repaved Highway 60 in New Mexico warms the air immediately above it the morning of April 24, 2004, creating the inferior mirage. Seven (or eight?) varying images of the vehicle precede it; some merged, some inverted, some not. The view was boldly captured from the centerline of the highway, complete with a tripod-mounted telescope and camera.

WHEN A MIRAGE CAUSES AN ILLUSION If you see a mirage on the highway ahead, but believe that you are seeing water, you are deluded, because the water—not the mirage—is an illusion.

WHEN AN ILLUSION IS PORTRAYED AS A MIRAGE In classic cartoons, characters suffering in a desert not only see an oasis, but experience relief from the heat and their thirst as they dive into water, relax on a lounge chair under a palm tree, and sip a cool drink, before it all suddenly vanishes. A mirage? No. An illusion? Yes.

WHEN IMAGES ARE "REAL"
Many people think that an accurate representation of an object is "real," while a distorted one is somehow "not real." Yet both are equally genuine. Think of your own multiple images in a mirrored elevator, or in wavy funhouse mirrors: Are you able to choose just one as the "real" you? Similarly, when we view a mirage, we are seeing real images of true objects, however many or varied its parts may be.

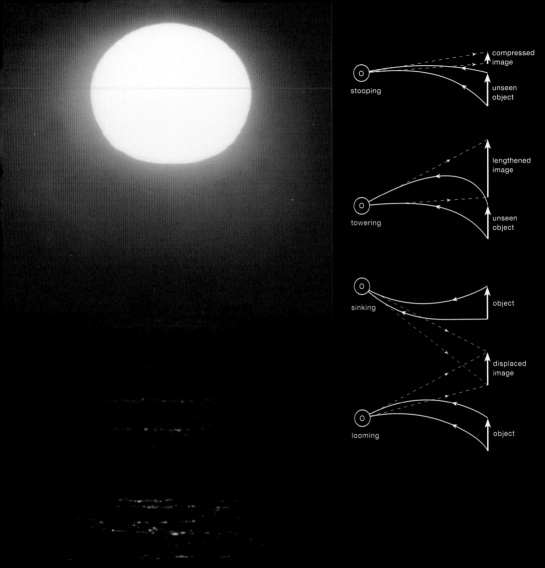

compressed
image

stooping unseen
 object

lengthened
image

towering unseen
 object

sinking object

 displaced
 image

looming object

Over large distances, light rays bend noticeably toward the higher density, so that the cooler, denser air is always on the inside of the curve, and the warmer, less dense air is on the outside of the curve; therefore, images are always displaced toward the warmer air. Whether the image is displaced upward or downward depends on the local density structure. Some of these effects are simple, but large refractive events cause objects to vanish, appear where they are not, or to vertically stretch or compress. Other effects cause more complex mirages in which images are inverted in one or more ways.

STOOPING AND TOWERING

When an object is tall, it may span a changing temperature/density profile. The light coming from the bottom of a tree, say, is bent more than the light coming from the top, which vertically magnifies the image, creating a towering image. Similarly, an object may be stooped or shortened by reverse conditions.

SINKING AND LOOMING

At times, warming of the air near the ground can cause a distant object normally hidden below the horizon to appear above it. This effect is called looming. And the reverse conditions—with cold surface air and warmer air aloft—can cause an object to vanish completely from view as its image sinks below the horizon.

When layers of air become more sharply defined in terms of temperature/density, they may create two images, one of which is inverted; these are called two-image mirages.

INFERIOR MIRAGES

When air temperature decreases rapidly with height, as it does on a sunny day over pavement, the image of a distant object is displaced downward in what is called an inferior mirage, the most commonly observed type of mirage. Blue light coming from the sky may be bent so that it appears as if it is coming from the surface of the Earth, looking like water on the ground. Sometimes the upper portion of cars, posts, or trees may be displaced downward, while their lower portions appear as inverted images below them, looking like reflections, although none have occurred. The strong bending of light in this case creates a double-image inferior mirage as the original objects are displaced in erect and inverted images. When the conditions for an inferior mirage are well developed, distant objects may completely vanish from sight, as the light from them deflects over the head of the observer.

← **LOOMING SUNSET** As the rays from a setting Sun reach our eyes, they bend downward through the lowest, densest portion of the atmosphere, following the curve of the Earth. In an everyday, ordinary looming mirage, rays from the bottom of the Sun are displaced upward more than those from the top portion, making the Sun appear oval and higher than it actually is. When we see the lower portion of the Sun just touch the horizon, the whole of it has already set. Careful scrutiny of this photo reveals a second looming image: that of an ocean freighter seemingly floating above the water's horizon directly under the Sun.

TOWERING RIDGES A gently sloping mountain range some forty-five miles to the south erupts in intangible buttes, mesas, and jagged cliffs seemingly to shadow the tree line in the foreground. A strong thermal inversion with a complex structure formed during the night over the Rio Grande Valley, giving rise to the towering images on the morning of September 15, 2005, as seen from Socorro, New Mexico.

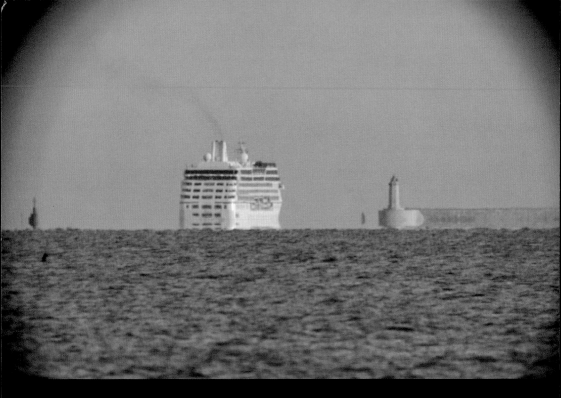

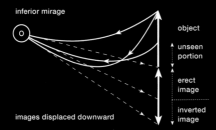

inferior mirage

O

object

unseen
portion

erect
image

inverted
image

images displaced downward

← INFERIOR MIRAGE An inferior mirage makes objects appear lower than their true positions. One part is inverted because light rays coming from the top of an object cross with those coming from the bottom. In this example, the image of the arrow's top is displaced twice: once right side up and once inverted. The bottom of the arrow can't be seen at all.

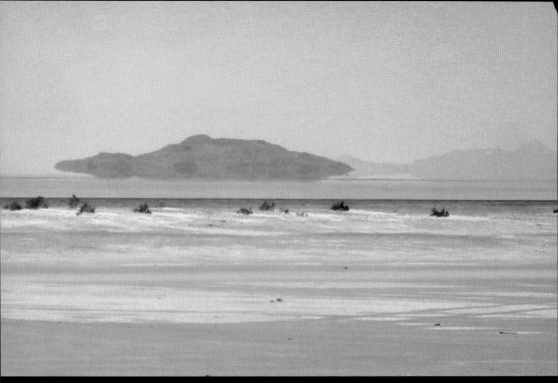

↑ MOBILE MOUNTAIN A rogue mountain seems to have detached from its moorings and is cruising the Bonneville Salt Flats in Utah on September 7, 2004. (Apparently, the mountain has a reputation, since its name is Floating Island.) In reality, however, a strongly heated layer near the ground is bending light downward into an inverted inferior mirage of the hump and the surrounding sky, isolating it from its immediate surroundings and obliterating the actual horizon. The more distant ridge, paler because of scattering, follows with its own distorted vanishing act. The dark horizontal line is a road.

↖ INFERIOR MIRAGE A stunningly clear inferior mirage inserts another four decks on the ocean liner, suspends buoys in the air, and lifts both lighthouse and land in erect and inverted images. The advection of cool, clear air from the east over the warm Ligurian Sea creates the perfect conditions for the visual aberration off the Italian coast of Marina di Pisa, as seen through a telephoto lens.

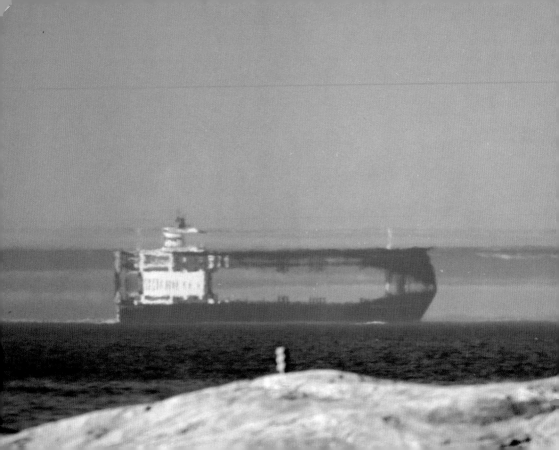

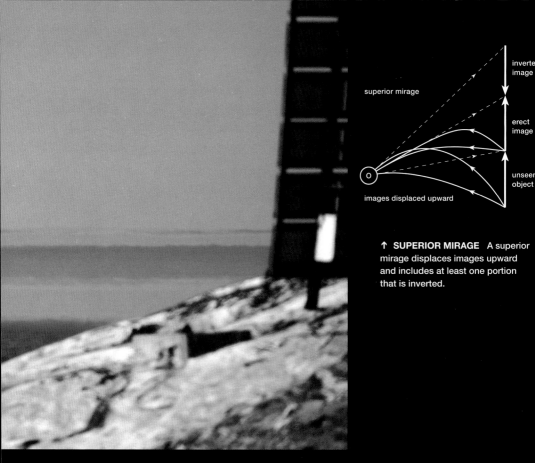

superior mirage

inverted image

erect image

unseen object

images displaced upward

↑ **SUPERIOR MIRAGE** A superior mirage displaces images upward and includes at least one portion that is inverted.

SUPERIOR MIRAGE A superior day in May in southwest Finland creates new sights to see—assisted by a telephoto camera lens.

↑ A freighter tends to business as usual while a viewer from the shore sees its hull replicated upside down.

Overleaf: The distant shoreline flips and caps itself in an obvious superior mirage.

LATERAL OR MURAL MIRAGES

In rare cases, when the temperature is constant with height, but dramatically increases laterally, as it might in the immediate vicinity of a strongly heated wall or cliff, the image of distant objects may be displaced sideways in what has been traditionally called a lateral mirage, essentially an inferior mirage turned on its side. A lateral mirage is also sometimes called a mural mirage.

SUPERIOR MIRAGES

A superior mirage occurs in a temperature inversion, and makes objects appear higher than their true positions. When the air temperature increases rapidly with height, as it often does over bodies of water in the summer, light from distant objects bends downward, and the images are displaced upward in a superior mirage. One part of the image is inverted and, depending on the variation and depth of the temperature inversion, may appear smaller, larger, or the same size as the real object.

A unique type of superior mirage results in ducting, in which the bending of the light within a thermal inversion is stronger than the curvature of the Earth itself, and rays traveling inside it can be continuously guided along the Earth's surface (as if in a duct) without ever escaping to space. Such ducting is like having magic spectacles that permit seeing around the edge of the Earth to very distant places. On the morning of August 18, 1894, the citizens of Buffalo, New York, were treated to the sights of downtown Toronto, complete with church spires, harbor, and a side-wheel steamer—sixty miles away across Lake Ontario. On July 17, 1939, Iceland's 4,715-foot-high mountain Snaefells Jokull was sighted from a ship at sea from a distance of some 335 miles! (Absent a mirage, the mountain is not visible beyond ninety-four miles.)

FATA MORGANA MIRAGE

One type of fascinating, extremely complex mirage is created in an unusual density structure in which vertically adjacent layers produce alternating towering inferior and superior mirages. This effect is caused by a temperature inversion above the surface, in which temperature first increases gradually with height, then rapidly, then more gradually again. Because the amount of distortion depends on the refraction through these differing densities, one small object may be greatly magnified, while another appears almost normal in size. The resulting mirage may make a low-sloping coastline appear as a cliff, and small boats as tall walls or buildings in the distance. Gaps in the images may appear as windows or bridges. Known as the Fata Morgana, it is an extreme form of complex towering that vanishes as soon as the temperature profile changes.

MOCK MIRAGES

When we observe the Sun or Moon near the horizon downward through a thermal inversion from a position above, and then—due to the Earth's curvature—out through it again below the horizon, another type of exceedingly complex mirage with three images may be seen. The denser inversion layer acts as a lens,

A spring Sun squashes, splinters, and sets in fragments over an open sea, as observed

THERMAL INVERSION LAYER In normal atmospheric conditions, the air temperature decreases with altitude (an average of about 3.5° F per thousand feet). But in an inversion of that profile, a layer of warmer air lies above cooler air. Because cooler air sinks and warmer air rises, such an inversion does not easily permit the mixing of air between the two layers and is as a result quite stable. As it concerns visibility, smoke or dust contained in one layer tends to stay at that level, which also affects how light is scattered and absorbed in it. As it concerns mirages, if the temperature/density differences between the layers are stark enough, light passing through the different layers will refract at differing angles, producing any number of fanciful images.

NOVAYA ZEMLYA MIRAGE Named after the far northern island of the Barents Sea, where it was first observed and reported, this ducting mirage forms near the end of the months-long arctic night, as the Sun peaks over the southern horizon weeks ahead of its scheduled arrival. It occurs as the Sun's light penetrates an extensive and extremely cold layer of air near the surface that is sandwiched between warmer layers, and bends in a superior mirage along the Earth's curvature far enough to emerge from below the arctic horizon, in an embracing but ultimately disheartening image of premature spring.

FATA MORGANA From the legendary tales of King Arthur and his court comes the story that the half sister of King Arthur was a fairy named Morgan Le Fay, who with magic could build castles and cities out of thin air. Evidence of this ability was quite regularly apparent to the southern Italians. Looking westward into the Strait of Messina, between the southernmost tip of Italy and the island of Sicily, they regularly noted the spontaneous appearance and disappearance of structures—buildings, viaducts, bridges, towers, indeed whole cities, as ethereal as light and air—as portions of rippling waves, rocks, and coastlines in the distance greatly distorted into realistic-looking structures, complete with people milling about them.

Such a complex mirage forms in the instability of a strong temperature inversion over a warm sea. Sporadic line-of-sight breakdowns in the density profiles give rise to rapidly shifting appearances of towers, pilasters, arches, and windows. This type of extreme towering mirage, so suggestive of a fairy world and magical castles in the sky, came to be known around the world as the Fata Morgana, after the legendary fairy Morgan.

FATA BROMOSA The Fata Bromosa (fairy fog) of the polar regions materializes as a featureless fogbank, a superior mirage of snow-covered expanses.

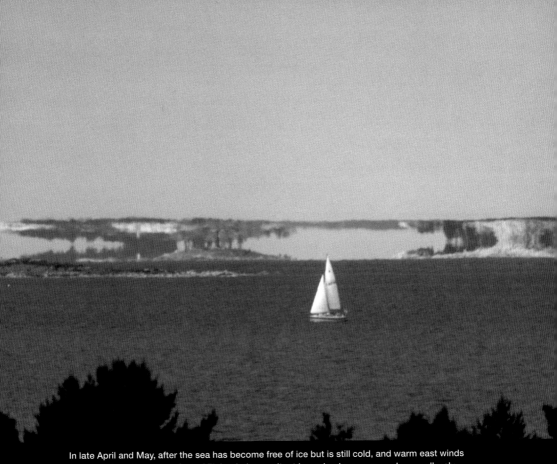

In late April and May, after the sea has become free of ice but is still cold, and warm east winds from Russia spill over the Gulf of Finland, the resultant inversion layer can produce endlessly fascinating mirages. In July a sailboat cruises the bay as a warm breeze from the land flows over the cool waters, constructing fairy castles from the islands fourteen miles away.

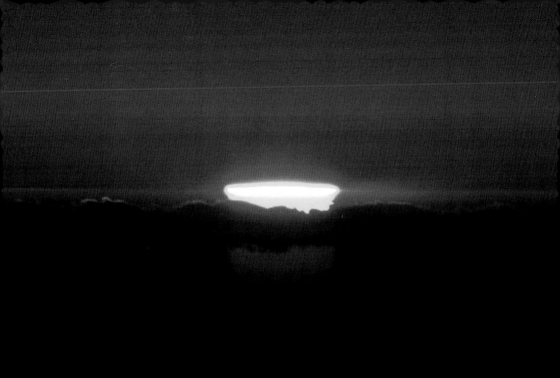

DOUBLE SUNSET As seen from the European Southern Observatory high in the Atacama Desert on Cerro Paranal, Chile, the Sun sets twice over the Pacific Ocean. It is not a reflection, but an inferior mirage that displays an inverted Sun in a layer of warm, less dense air above the water's surface. The upper Sun is flattened but shines brighter through a shorter path through the atmosphere, while the lower Sun is less distorted but dimmer from its journey through a thicker, dustier cross section of the atmosphere.

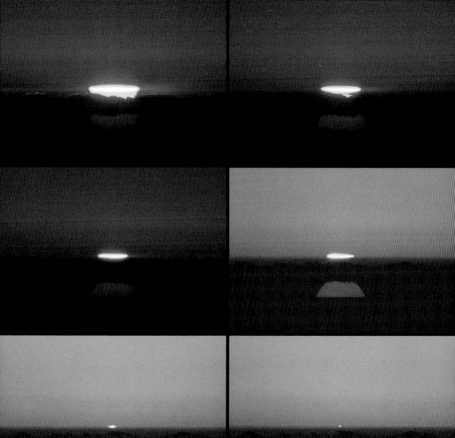

forming an inverted image of a strip of the sky parallel to the horizon. To distinguish it from the classical inferior and superior mirages with two images, it's been dubbed the mock mirage. When ducting occurs within the inversion, it can produce obscured strips or blanks in the inverted images that fill in as the Sun or Moon sets, as well as some surprisingly spectacular effects, including red and green flashes; mushroom-shaped suns; and even sharply edged rectangular Suns whose sides collapse to form an hourglass, which in turn splits into a pair of horizontal red-orange lines before vanishing.

Looking upward through an inversion reveals another variant of the mock mirage. It is called the late mirage because it appears after the Sun has "set" on the upper side of the duct and then reappears below it.

SUNSET EFFECTS

If you've ever gazed at a sunset or sunrise, you may have noticed a common effect of refraction in the apparent flattening, or oblateness, of the Sun near the horizon, as it appears more oval than circular (see the looming sunset image on page 148). In the moist, stable conditions common over the oceans, the Sun may appear to stratify into strips like a stack of pancakes, or into ragged edges, looking much like a huge Chinese lantern, and constantly change shape as it rises or sets.

GREEN FLASHES

In clear, stable air with a normal, uniform decrease in temperature with height, a twice-daily looming act positions the image of the Sun just above the horizon, when it is actually below it. And because red light is refracted less than blue light, a photograph of the setting or rising Sun properly—and carefully—taken through a telescope may reveal a red rim on the bottom and, in exceptionally pure arctic air, a blue rim on the top. In normal conditions, however, that blue is lost through scattering on its way to our eyes, and the upper edge of the low Sun is instead tinted green. Usually, this green edge is not visible to the unaided eye, but with just the right towering conditions provided by an inferior mirage, the separation between green and red wavelengths is greatly enhanced, and the patient and persistent observer may be rewarded with a brief but bright emerald flash.

When the temperature decreases rapidly with height, an inferior mirage produces an inverted image of the Sun below the erect one. As the Sun sets, the upper and lower images converge, touch, and eventually overlap to form an omega-shaped Sun (after the Greek letter Ω). In the last seconds just before the image sets and vanishes, a narrow band of the sky—where the erect and inverted images join—greatly magnifies the green rim into a narrow green glint that is visible to the unaided eye.

A green flash may also appear in a mock mirage through the courtesy of a weak temperature inversion just a few feet above the surface, in which the top green rim of the Sun is greatly magnified at the inversion boundary. Other manifestations of this little-understood phenomenon include a sustained green glow of a larger portion of a distinctly hourglass-shaped Sun, and an emerald ray that shoots upward coinciding with the main flash.

FLASHES OF UNDERSTANDING Popularized by Jules Verne in his 1882 tale *Le Rayon Vert*, in which the hero chases the elusive phenomenon, the fascinating green flash is still poorly understood. Rare in occurrence and elusive to the would-be observer, it may occur shortly before sunrise or after sunset, in conjunction with a mirage and/or a thermal inversion. Research and study has only recently uncovered some of its mysteries, identifying at least six different kinds, based on distinctive characteristics and suspected causes. Most last just one to two seconds.

inferior mirage flash	top rim edge of oblate Sun
mock mirage flash	pointy horizontal sliver detached from top of Sun
sub-duct flash	upper portion of an hourglass-shaped Sun; lasts up to fifteen seconds
green ray	beam of light extends upward from a green flash, or is seen immediately after sunset
cloud-top flash	observed as Sun sets through coastal fog or cloud bank
Fraser flash	observed through lifted temperature inversions over hills

INFERIOR MIRAGE GREEN FLASH This elusive inferior mirage green flash was captured on October 30, 2001, at Civitavecchia, Italy, through a five-inch diameter telescope.

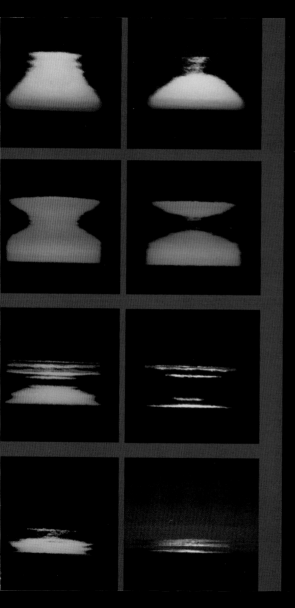

THE MALLEABLE SUN Infinite in variety and exceedingly complex in the making, the Sun's own light betrays its maker as it assimilates and distorts in its journey through the Earth's atmosphere.

Overleaf: **MOONSET** The atmosphere is no respecter of heavenly bodies. A multiple exposure of the setting Moon reveals its capricious light-bending strength, as observed on March 11, 2006, from the Ligurian Sea beach at Pisa, Italy.

MOCK MIRAGE GREEN FLASH An inversion layer acts as a lens to form an inverted image of a strip of the sky parallel to the horizon. The inverted image causes a piece of the Sun to appear to separate from the main disk and flash green before vanishing.

SCINTILLATION AND SHIMMER

When stars, planets, and other luminous nighttime sky objects outside our atmosphere are observed, rapid variations in their apparent brightness, color, and position may occur. Such astronomical scintillation is caused by rather small parcels or layers of air, whose temperatures (and hence densities) differ slightly from those of their immediate surroundings. As these parcels are moved across our line of sight by the wind, the light from these distant objects refracts through them, producing the irregular fluctuations we see. Scintillation is always more pronounced in objects nearer the horizon than nearer the zenith, due to the greater mixing of the air nearer the surface. On clear, cold nights, stars appear brighter as their light reaches our eyes relatively unmolested by turbidity and density anomalies. When this same fluttering effect is observed in objects within the atmosphere at the Earth's surface, it is called terrestrial scintillation, or shimmer.

LOCATING MIRAGES

Mirages appear whenever the momentary conditions allow for them. Surprisingly, such conditions are quite widespread and happen fairly frequently. The trick, as always, is knowing where and when to look. Compared to the expanse of the entire sky, mirages are tiny. They are normally seen near the horizon, and show image displacements and distortions of less than .5° (which is about the same as the angular widths of both the Sun and Moon in the sky.) Look at the desert mirage image on page 173 to note how small it really is. Calm, stable weather is most conducive to mirage formation allowing air layers of differing densities to settle with little interaction between them. Even a small breeze can mix the air into a homogenous blend and destroy mirages.

Mirages are not dependent on warm temperatures per se, but rather on the rate of temperature change due to height or the difference in temperatures between adjacent or alternating layers of air. The greater the rate of change, the greater the light refracts on its way to our eyes.

The most likely places to look for such stark temperature profiles are near the horizon where:

• a strongly heated flat surface radiates its warmth to the immediately overlying still air—such as above the desert floor, or above the dark pavement of a road during the day, or over a calm lake at night.

• a very cold surface cools the air above it, as in arctic regions, or is overlaid with much warmer air, as when lake or sea ice thaws in springtime.

• the observer's perspective enhances the temperature gradient between the object and the observer, such as when you peer at a distant object over the crest of a hill; or from a lower angle, increasing the distance the light travels through the most sharply differentiated layer to the eye. The twice-daily varieties of low-Sun phenomena are observed from such low-angle perspectives.

SHIMMERING ZEBRAS Shimmer through the bottom few feet of the air blurs and blends the legs of a curious zebra herd at the dry, mud-caked edge of Lake Ndutu in the southern Serengeti, Tanzania, on February 4, 2005.

In the zebras' natural habitat in the savannah, where the big-cat predators must attack from out in the open, the zebra's coloration helps it blend in, both biologically and physically. The hunter cannot capture the entire herd, so must target one individual from among it. But when the zebras congregate together, their collective, wavy vertical stripes make it difficult for the predator to make out where one individual ends and another begins. Adding to her troubles, the lioness must view her prey from a distance, through the strongly heated, shimmering air of the surface, which further distorts her wavy perspective and advantage.

• a strong temperature inversion forms (cooler air below warmer air). This is evident where smoke stays at the ground level or stops rising at a certain height, revealing an inversion aloft. High pressure areas (fair weather) may also form inversions at the base of a sinking layer of air.

OBSERVING MIRAGES

Because mirages are relatively small, the observant seeker must look with distance eyes for detail among likely locations, and be able to distinguish what is normal from what is not. To some degree, this depends on your memory of the scene without a mirage, or on a mental construction, because all you can see is a mirage—or not a mirage! Typically, however, the patterns of looming, sinking, towering, stooping, inverting,

A TRUE DESERT MIRAGE While mirages can appear anywhere in the world, a motor convoy is engulfed by the overwhelming sky in the Great Selima Sand Sheet, a flat, sandy plain of some 15,000 square miles spanning the Egypt-Sudan border. Strong heating of the sand grills a layer of hot air at the surface that cools rapidly with height, creating inverted images of the Land Cruisers beneath them and bending skylight downward in an inferior mirage in the desert in March 2003.

and other distortions and displacements are striking enough to recognize. Binoculars or a spotting scope help isolate and magnify the differences.

PREDICTING MIRAGES

Mirage-creating conditions are calm, clear weather with good horizontal visibility, and also vary according to such non-weather-related conditions as topography, natural ground cover, man-made structures, and even the angles of the Sun and the observer. However, because mirages are most closely associated with strong vertical-temperature gradients, we are better able to predict a sighting when we know the kinds of weather with which they are associated. The greater the temperature differences in the bottom layers, the greater the bending of light, and the more dramatic the images.

Inferior mirages settle where temperature decreases drastically with height. These effects are most likely to happen in dry, stagnant air masses, developing low pressure areas, and on bright, sunny days when there is strong heating of the surface (which is increasingly likely the higher the Sun is in the sky, as on summer afternoons). Generally, in the absence of other active weather systems, the surface warms in the daylight, from an hour after sunrise to an hour before sunset, and may set the stage for downward displacements of images.

Superior mirages sprout in thermal inversions, where temperature increases with altitude. Such conditions are associated with stable air masses; high pressure areas; clear nights when the surface radiates heat away rapidly; clear days when the air over a body of water heats up much faster than it does next to the cooler water; the passage of a cold front or cold advection (horizontal motion of air); or the downslope of colder air into valleys at nighttime. On a daily basis, stable conditions are more likely to exist as the surface cools, from an hour before sunset to an hour after sunrise.

INTERPRETING MIRAGES

Unfortunately, because a mirage is a momentary figment of the current state of the atmosphere at a particular place and time—and not a sign of things to come—about the only thing we can infer from its appearance is that it is an indication of the conditions in which it forms. Consider it an instant snapshot of the current weather in a particular locale.

ANALYZING

What story can you tell from this series of images? Read the photographer's tale on page 228.

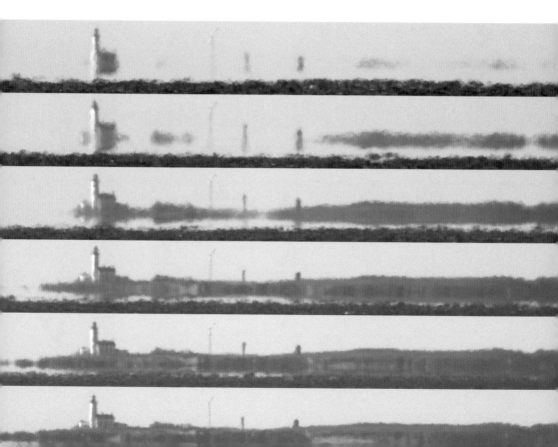

Fire in the Sky
Lightning and Other Discharges

Boldly erratic and tantalizingly beautiful, lightning stings the air and zaps the ground as a summer storm menaces Tucson, Arizona. As the Sun retreats below the horizon, a peacefully striated twilight settles even as its energy charges the advancing storm.

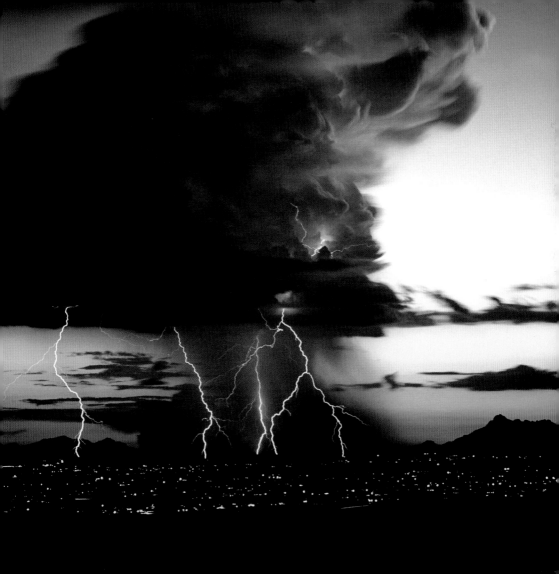

A vehement gash ignites a darkened sky and detonates the jumbled air. Jolting repercussions carouse wildly as the storm recharges and amasses dynamic potency for more. At once ephemeral and dazzlingly real, lightning's contribution to the kaleidoscope sky strikes with gusto, strength, and vibrancy unmatched by the mere spectrums and streaks of redirected light waves.

Derived from different processes than are the common colors of the sky and its gallery of arcs and bows and rings and things, the energized array of strokes and glows swells the scope of invigorated light spattered on the planet. In this chapter we examine the sources, forms, and natures of such spastic and chromatic electrical discharges.

Unpredictable and chaotic, utterly random and deadly dangerous, lightning is a continuous presence on Earth. It is closely associated with all the major natural disasters of volcanic eruptions, intense forest fires, heavy snowstorms, and hurricanes, but is the central defining characteristic of a thunderstorm. At any one moment, there are some 1,800 active thunderstorms on the planet—sixteen million every year—with fifty lightning flashes around the globe occurring every second.

To produce lightning, a lowly cumulus cloud must grow tall enough and strong enough (six to ten miles high) to contain the crucial element of ice; a rainstorm that fails to produce ice also fails to become a thunderstorm. Ice varies from minute crystals to several-pound hailstones; but during the explosive growth stage of a thunderstorm and the start of precipitation, a static charge builds up as ice crystals and water droplets grow, interact, and collide in the numerous and powerful updrafts and downdrafts. The smallest ice particles near the top of the cloud tend to accumulate a positive charge, while larger, heavier water droplets fall to lower parts of the cloud. These acquire a negative charge, which in turn induces a positive charge on the ground for several miles around the storm. The voltage difference between areas of opposite charges can reach up to 7,500 volts over the distance of just one inch, and millions of volts over the entire cloud. Once the voltage difference exceeds the insulating capacity of the air, a lightning stroke occurs to complete the electrical circuit and discharge the buildup of static electricity, marking the official transformation from rain cloud to thunderstorm.

The first lightning flash of a thunderstorm is generally contained entirely within the cloud. A luminous leader traveling between charge centers initiates the discharge, and a lightning strike illuminates the interior

VOLTS VS. AMPS Ampere: a measurement of the flow of electric current.
Volt: the pressure that pushes electrical charges through a conductor.

The amount of current depends on the voltage and the conductivity of the object struck. As it applies to lightning, a person standing on wet ground is a better conductor of electricity than someone standing on dry ground. A current of one or two amps is usually enough to stop the heart from beating.

of the storm for just .2 of a second, with several-millisecond pulses of higher intensity during the brief light show. The charge, estimated to be a few thousand amperes, travels about five to ten miles per second.

What our eyes see as a single stroke of cloud-to-ground lightning is usually several strokes in rapid succession, in both directions. The series begins as a stepped leader emerges from the thundercloud. Composed of luminous electrons, it moves in discrete steps of about 150 feet at a time, for just one-millionth of a second, pausing about fifty microseconds between steps, depositing a charge along a branching channel toward the ground. As it nears the ground, the stepped leader may draw a positively charged streamer upward, to intercept it and complete an ionized path to the ground. The cloud is then short-circuited and a brilliant return stroke flashes upward at about 60,000 miles per second, carrying 30,000 to 200,000 amperes, peaking in just a few millionths of a second.

Such an instantaneous rise in current instanteously heats the air in the lightning channel to temperatures exceeding 50,000°F. The heated air explosively expands, compressing the surrounding clear air, generating a shock wave, which becomes an acoustic wave as it propagates away from the channel. The noise is thunder. Because sound travels relatively slowly, thunder heard as a sudden "crack" has been generated close by. Rumbling reverberations that follow may have actually been generated first, several miles away, at the start of the lightning stroke.

Upon the completion of the first return stroke, small streamers occur in the cloud as precursors to the next stroke, a luminous dart leader emerges and follows the same track to the ground without branching, and a second stroke occurs. This is followed by another return stroke upward. Cloud-to-ground lightning flashes typically consist of three to four individual strokes, and at times as many as twenty or more, all in less than a second, requiring the use of high-speed cameras to delineate.

BALL LIGHTNING

Ball lightning is an extremely rare, luminous ball of light, one to three feet in diameter, that may move rapidly among or through objects, or float in the air before exploding or simply dissipating. It is usually preceded by a lightning flash, lasts a few seconds to a few minutes, and causes little or no damage. Although it has been reported anecdotally for thousands of years, because its formation has eluded and frustrated theoretical scientists, it is the least understood atmospheric phenomenon.

Many theories exist, but one interesting concept deserving further study postulates that when lightning strikes soil, it creates a hot channel of silicon vapor from silicon oxide and carbon in the soil. The hot vapor is then ejected out of the soil in a vortex ring similar to a smoker's puff. Taking on a spheroid shape, it continues to oxidize and stay hot and visible for an extended period as it floats about.

ST. ELMO'S FIRE

Positive charges streaming toward an area of negative charges in the air or clouds may generate a luminous green to bluish-white glow or dancing flame that lasts up to a minute. Technically called a corona

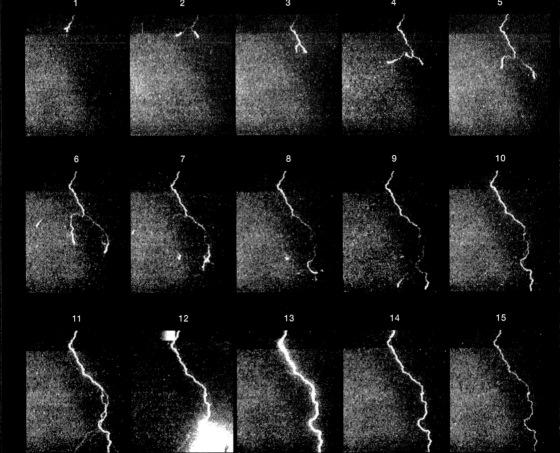

FAST LIGHTNING FACTS

TYPICAL RETURN STROKE TEMPERATURE: about 50,000° F—five times hotter than the surface of the Sun
ELECTRICAL CURRENT: up to 200,000 amperes per stroke
TYPICAL VOLTAGE: 100 million volts per stroke
AVERAGE PEAK ENERGY: 1,012 watts per stroke
AVERAGE STROKE LENGTH: six miles—farther than thunder is usually heard
LONGEST STROKE LENGTH RECORDED: 118 miles in the Dallas-Fort Worth, Texas area
TRAVEL SPEED: 60,000 miles per second
AVERAGE TRAVEL TIME TO DESTINATION: 1/10,000th of a second
AVERAGE NUMBER OF STROKES PER FLASH: four
FREQUENCY: About 100,000 thunderstorms occur in the U.S. annually; an estimated 1,800 are in progress at any moment throughout the world, producing some fifty flashes per second.

LIGHTNING STROKE SEQUENCE As a thunderstorm approached and darkness descended on July 21, 1994, researchers at Los Alamos National Laboratory in New Mexico photographed a lightning bolt at 1,000 frames per second, with 100-microsecond exposure time on each consecutive frame. This fifteen-frame sequence shows a cloud-to-ground stroke, from a distance of about one mile, that has a series of stepped leaders propagating downward, followed by an upward-propagating main return stroke.

Prior to any discharge of lightning, positive charges accumulate near the top of the cloud; negative charges gather near the cloud's base, and induce a positive charge on the ground.

In frames 1 through 9 a stepped leader emerges from the cloud, carrying negative charges earthward at a speed too fast for the eye to see. Although not recorded in this instance, many times a positively charged streamer from a tree or tall structure may form and meet the stepped leader, creating an ionized channel. In frames 9 through 11 multiple filaments are intertwined as the leader reaches the ground.

Frame 12 records a brilliant ground-to-cloud return stroke flashing upward, carrying positive charges; a shock wave is created from the extreme heating of the air in the channel and thunder is heard. The stroke's brilliance overwhelms the camera's sensitivity and causes the bright artifact near the top of that image.

The current fades in frames 13 through 15 without any further strokes. In many other discharges, a dart leader forms a cloud-to-ground strike following the same track downward without branching, and a second return stroke occurs upward. The dart leader–return stroke exchange may be repeated several times to constitute one lightning flash. Typical total stroke time elapsed: 30 to 300 microseconds. Typical total flash time elapsed: less than one-half-second.

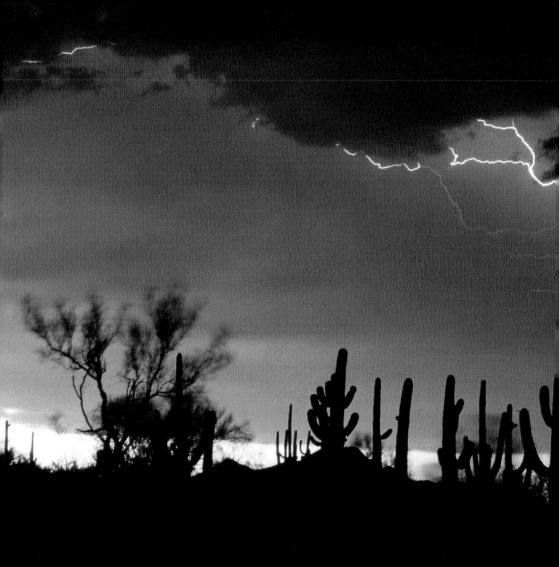

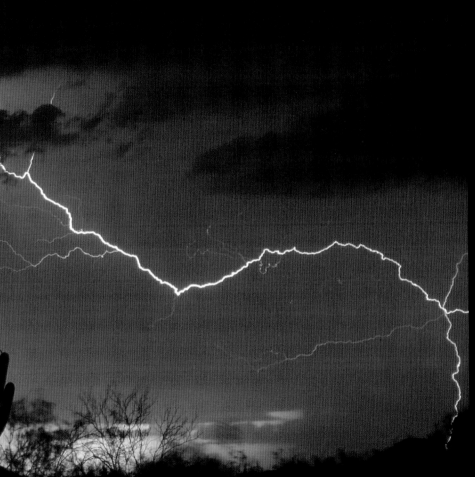

A LONE BOLT STRIKES OUT The lower parts of a thundercloud tend to accumulate negative charges, which induces a positive charge on the ground. When the voltage difference exceeds the insulating capacity of the air, a lightning stroke completes the electrical circuit and discharges the buildup of static electricity. A strong but localized storm in late August 1997 is backlit by the setting Sun near the Silverbell Mountains northwest of Tucson, Arizona.

OBSERVING LIGHTNING Lightning is deadly. Each year it kills more people than tornadoes and hurricanes combined, and is the only hazard that may both precede and follow the storm itself. Because of its instantaneous and capricious nature, no place from which to observe lightning is entirely safe, but some locations are safer than others.

The safest place is from inside a large, enclosed building with plumbing and electrical wiring which, if struck, conducts the deadly current around you to the ground. Stay away from corded telephones and electrical appliances. Outdoors, the next best place from which to observe lightning is an enclosed metal vehicle, providing you are not in contact with any conducting pathways to the outside, such as the radio or keys in the ignition.

FLASH TO BANG COUNTDOWN Since light travels at over 186,200 miles per second, the lightning flash is seen the instant it occurs. Sound travels much more slowly, at about one-fifth of a mile per second. Count the number of seconds between seeing the lightning flash and hearing the thunder, and divide by five to estimate how far away the lightning stroke occurred, in miles.

If the count is ten to fifteen seconds, the flash was two to three miles away: too close for comfort. Successive lightning strokes can be two to three miles apart, and you could be the next target. Don't be lulled into complacency by thinking the storm is still a ways off. Lightning may leap quite a distance through clear air to strike several miles away from the storm, in what is the proverbial "bolt from the blue." The rule to remember is the 30–30 Rule: When you see lightning, count the seconds until you hear thunder. If that is thirty seconds or less, you're in the danger zone; seek appropriate shelter. Wait for thirty minutes after the last lightning strike before resuming normal outdoor activities.

BEAD LIGHTNING Cloud-to-ground lightning in which some sections of the channel remain luminous longer than others; also called pearl or chain lightning.

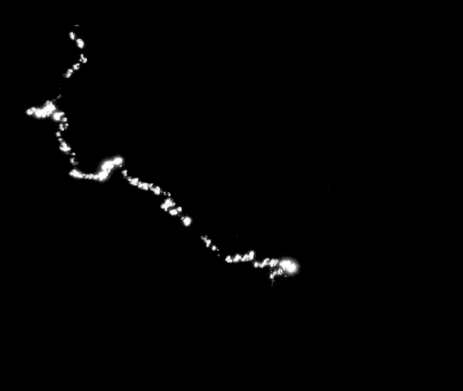

A lightning bolt beads out after striking the WVAH television tower near St. Albans, West Virginia, on April 17, 2006.

BLUE JETS Narrow cone-shaped blue flares ejected from the top of a thunderstorm into the strato-sphere; not directly associated with cloud-to-ground lightning.

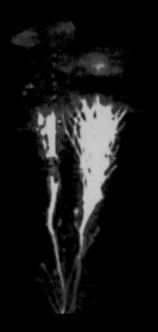

Captured on high-speed video with a night-vision intensifier on the night of September 14, 2001, this blue jet flashes over the Atlantic Ocean northwest of Puerto Rico. In just eight-tenths of a second, it reaches all the way to the ionosphere, forty-four miles high, and fills over 1,400 cubic miles of atmo-sphere. Reprinted by permission from Macmillan Publishers Ltd: *Nature* Vol. 423, copyright 2003.

FORKED LIGHTNING Typical cloud-to-ground (CG) lightning comprises about 20 percent of all strikes; it is also called streak lightning.

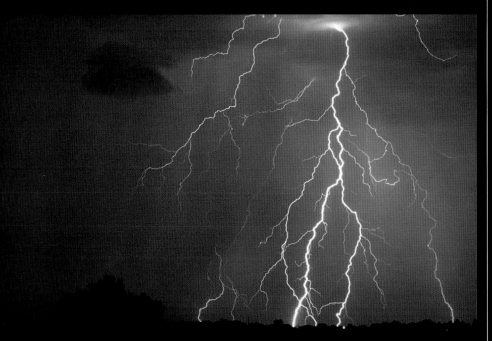

Like the squiggly, anchoring roots of an old tree, the tendrils of cloud-to-ground lightning branch out from the main channels as the bolt seeks to ground itself. Clearly revealing its structure by striking outside of the rainfall, this magnificent strike was captured on the stormy night of July 16, 2005, in Socorro, New Mexico.

HEAT LIGHTNING Cloud-to-ground flash seen from a distance; no thunder is heard; appears red or orange for the same reason as does the setting Sun.

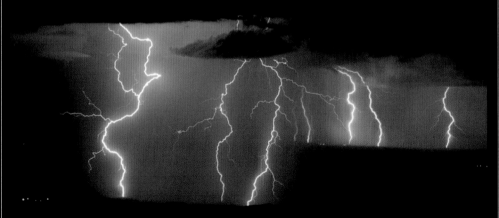

A time-lapse photo of lightning strikes near Santa Fe, New Mexico, displays the difference in flash colors between the closer bolts in the valley (left) and the more distant strikes on the horizon (right), some ninety miles away.

HOT AND COLD LIGHTNING Refers to the observation that some lightning strikes cause fires and others do not. This fact is due to differences in the amount of current sustained in a particular flash.

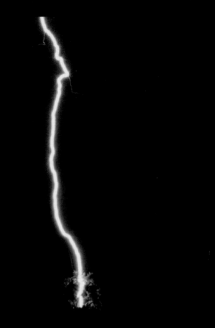

In a direct strike to a live tree, sap is instantaneously vaporized in the heat and expands explosively, often shredding and blasting off a strip of bark along the bolt's pathway to the ground.

NEGATIVE LIGHTNING Lightning that originates from the negatively charged area low in the thundercloud.

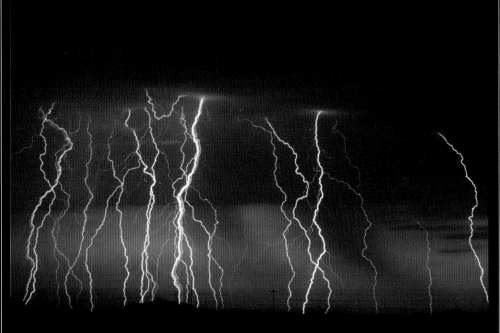

Zigzagging javelins repeatedly stab the ground in a red-tinted barrage over Tucson.

POSITIVE LIGHTNING Lightning that originates from the top of the cloud in the positively charged area is particularly dangerous because it is generally longer in duration, carries a higher peak current, and can strike into clear air up to ten miles away.

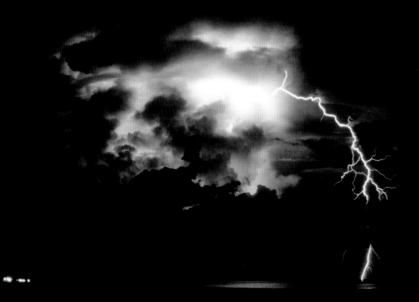

A 4 A.M. jolt lashes out boldly from the upper reaches of a summer tropical "wet season" storm in December 2002 near Darwin, Northern Territory, Australia. A two-minute exposure reveals a bit of the storm's dark drama.

RED SPRITES Distinctively shaped red flashes discharging from the tops of thunderstorms occurring simultaneously with positive cloud-to-ground strokes.

Rocket-like plumes launch directly over the top of a vast thunderstorm complex over Oklahoma on July 22, 1996. Reaching some sixty miles high in just a few milliseconds, the red sprites' tendrils trail half that distance to the top of the thunderstorm cloud. These fireworks capped a spectacular heavenly show in which about 400 sprites "flash danced" that dark and stormy night.

RIBBON LIGHTNING Rare form of cloud-to-ground lightning that occurs in strong wind blowing perpendicular to the line of sight, spreading the channel sideways as successive strokes follow it, widening the observed flash.

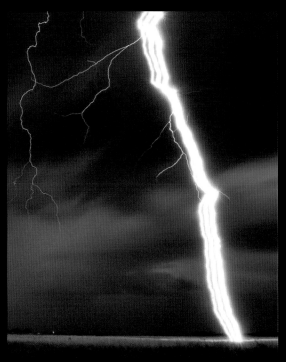

Taken from dangerously close range near Granite, Oklahoma, the photo of this stroke displays the classic ribbon effect as the bolt's return strokes are pushed sideways by the wind on May 30, 2006.

SHEET LIGHTNING Intracloud flash in which no branches of the stroke are visible.

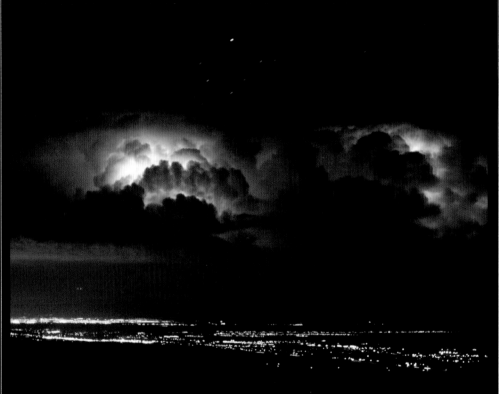

A massive cumulonimbus flashes its internal strife over Albuquerque, New Mexico, some forty-five miles away. The green glow at the cloud's base is scattered light from the city.

ST. ELMO'S FIRE A luminous greenish to bluish-white glow above pointy objects, caused by the soft glow of an electrical field as positive charges stream skyward toward negative charges in the cloud; also called a corona discharge.

A dying storm over the Langmuir Laboratory's two-mile-high mountaintop observatory for lightning research in New Mexico generated a large electrical field and St. Elmo's fire off the tip of an antenna mast on August 21, 2006.

discharge, the effect was named by Mediterranean sailors who regarded it as a good omen from their patron saint, Elmo, because it tended to appear on the yardarms and mast tips during the latter stages of a violent thunderstorm, signaling the end to stormy seas. Despite its nonconsuming nature, its eerie glow emanating from pointy objects such as church steeples and metal weather vanes has led more than one observer to mistakenly cry, *"Fire!"* Aircraft flying through thunderstorms and hurricanes often develop the discharges from the propeller, antennas, wings, and sometimes the entire fuselage.

RED SPRITES, BLUE JETS, ELVES, AND TROLLS

In the upper reaches of a large thunderstorm thrives a newly discovered race of faint optical marvels called Transient Luminous Events (TLEs). This race's vividly named constituents conjure up some lively and magical fairy-world imagery which, due to their whimsical, fleeting natures—and until we know more about their physical properties—actually seems somehow appropriate. Red sprites, blue jets, ELVES, and trolls are upper-atmospheric discharges that have only recently been documented using low-light-level television technology, and may prove to be quite common. Further research hopes to more accurately define the role of TLEs in the global electrical circuit and their possible contributions to the formation of the Earth's protective ozone layer.

Red sprites are large flashes that appear directly over an active but decaying thunderstorm at the exact moment as positive cloud-to-ground lightning strokes appear. Lasting no more than three to ten milliseconds, they flash in groups from above the cloud tops to almost sixty miles high, as brightly glowing clusters of crimson columns or rocketlike plumes. Trailing downward from their highest parts are often bluish filamentary tendrils, resembling those of a jellyfish, which may drop as low as twenty miles.

Blue jets are ejected in narrow cones from the top of the most electrically active core of the thunderstorm and reach heights of twenty-five to thirty miles before vanishing after a relatively long lifespan of a few tenths of a second. Blue starters are brighter but shorter jets that over regions where large hailstones fall.

ELVES are huge, disk-shaped regions of luminosity that expand up to 300 miles across and vanish in the span of less than one millisecond. They are thought to associate with cloud-to-ground lightning when a large electromagnetic pulse is released into the ionosphere. Discovered in 1992 with a low-light video camera aboard the space shuttle, ELVES get their name from the acronym for **E**mission of **L**ight and **V**ery low frequency perturbations due to **E**lectromagnetic pulse **S**ources.

Sprite halos are glows shaped like ELVES that precede red sprites and flash downward for a millisecond.

Trolls resemble blue jets but are red and seem to shoot off after the tendrils of especially vigorous red sprites reach downward toward the cloud tops.

Superbolts or gigantic jets shoot upward from cloud tops nearly sixty miles into the upper atmosphere and spread out to form shapes resembling giant trees or carrots.

LOCATING LIGHTNING AND TRANSIENT LUMINOUS EVENTS Lightning is found wherever thunderstorms roam. In a thunderstorm, lightning may originate from any part of the cloud. The most common flashes are contained entirely within the cloud and comprise up to 80 percent of the strikes. Negative lightning issues from the lower portion of the most electrically active core. Positive lightning, which originates in the upper part of the cloud, tends to be the most dangerous as its strokes generally are the largest and longest, and carry the greatest charge.

Red sprites, blue jets, and ELVES are distinctively shaped upper-atmospheric discharges from thunderstorms that have only recently been documented using low-light-level video technology. Along with several other electrically generated optical phenomena, they are collectively known as Transient Luminous Events (TLEs) and are the subjects of ongoing research.

OBSERVING SPRITES AND JETS The Geophysical Institute of the University of Alaska, Fairbanks, which conducts research on TLEs, offers the following pointers for observing sprites and jets:

1. A clear view above a thunderstorm is required. This generally means the thunderstorm activity must be on the horizon. Additionally, it must be completely dark (no longer twilight) and there must be little intervening cloud cover.

2. The best viewing distance from the storm is 100 to 200 miles. At these distances sprites will subtend a vertical angular distance of 10° to 20°.

3. Your eyes must be completely dark-adapted. If you can see the Milky Way, then it is probably dark enough and your eyes have adapted enough to see sprites.

4. Fix your gaze on the space above an active thunderstorm. Do not be distracted by underlying lightning activity in the storm. Block out the lightning and the cloud itself with a piece of dark paper.

5. Sprites are very brief flashes just on the edge of perceptibility. They occur too quickly to follow with your eyes, but their strange vertically striated structures and dull-red color may be perceived.

6. Patience is rewarded. If the right kind of storm is present and your viewing angle is favorable, then there is a greater likelihood of seeing a sprite than of seeing a comet or shooting star.

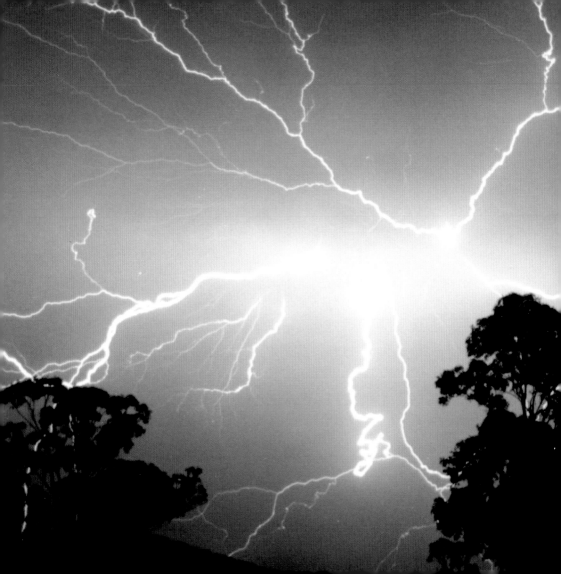

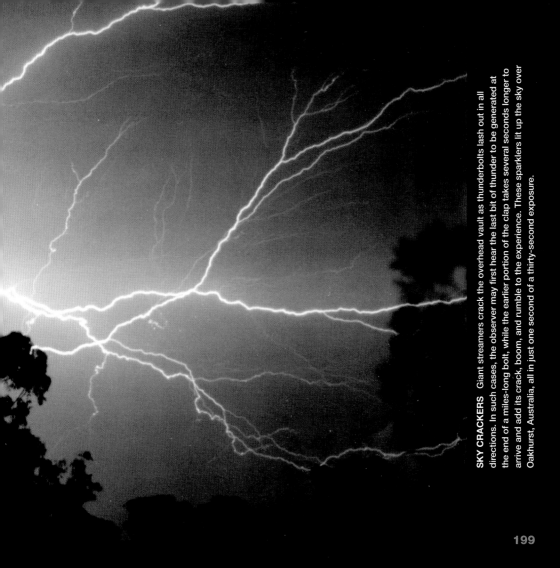

SKY CRACKERS Giant streamers crack the overhead vault as thunderbolts lash out in all directions. In such cases, the observer may first hear the last bit of thunder to be generated at the end of a miles-long bolt, while the earlier portion of the clap takes several seconds longer to arrive and add its crack, boom, and rumble to the experience. These sparklers lit up the sky over Oakhurst, Australia, all in just one second of a thirty-second exposure.

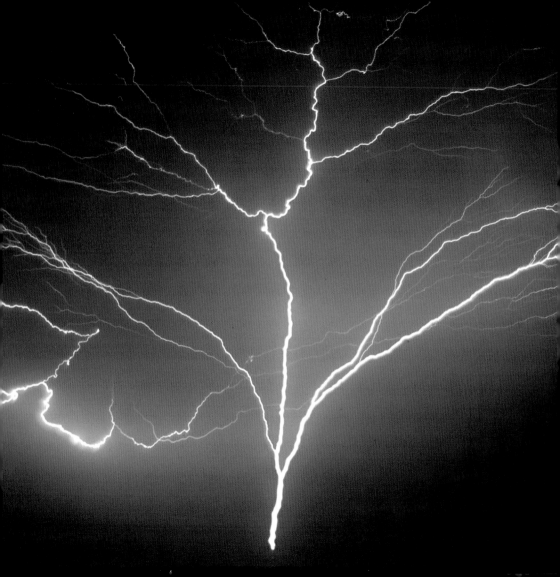

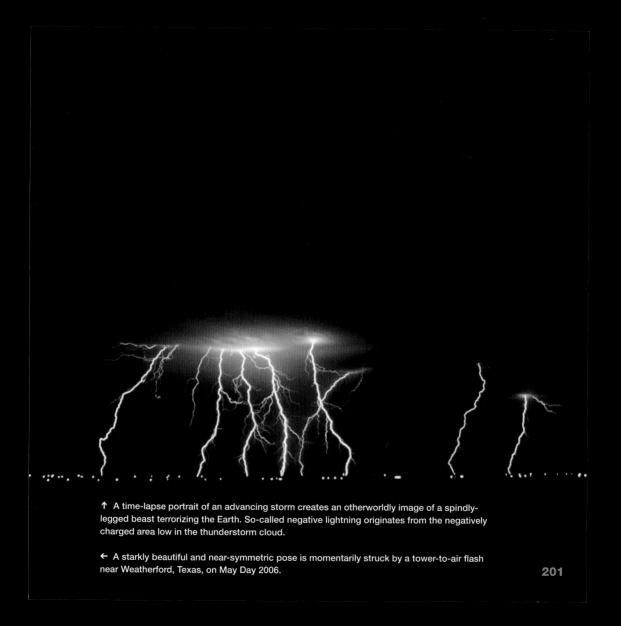

↑ A time-lapse portrait of an advancing storm creates an otherworldly image of a spindly-legged beast terrorizing the Earth. So-called negative lightning originates from the negatively charged area low in the thunderstorm cloud.

← A starkly beautiful and near-symmetric pose is momentarily struck by a tower-to-air flash near Weatherford, Texas, on May Day 2006.

PREDICTING LIGHTNING

We wish! Lightning detectors can tell us where strikes have already occurred, but beyond knowing that lightning typically strikes the tallest objects and best conductors of electrical current, predicting the exact moments and targets of strikes is not within the realm of current science.

However, methods for predicting the formation and movement of thunderstorms and other severe weather events have come a long way in the past years, as has the ability to inform the public of their current whereabouts. Through radio, television, and internet outlets, the monitoring and alert systems have never been more far-reaching. In the United States, NOAA Weather Radio broadcasts continuous weather information in customized reports for your locality. Weather Radio receivers can be purchased at many electronic retail stores and boat and marine-supply outlets.

INTERPRETING LIGHTNING

We can gauge precious little about current and future conditions whenever we see lightning.

The very hot discharge of lightning creates white light, like the Sun does. When viewed from a distance, however, the light may appear yellow, green, or even red, depending on the amount of air, water, dust, and pollutants that scatter its wavelengths on its way to our eyes, which in turn reveals atmospheric conditions between each of us and the storm.

On the other hand, due to its in-your-face unpredictability, there are some things we definitely do not know. We don't know that an increasing number of strikes means an increase in the storm's intensity, or that a decrease in lightning corresponds to a decrease in storm intensity. To the contrary, research indicates that there is no reliable relationship between lightning intensity and storm intensity!

Perhaps the only reliable interpretation an amateur observer can draw from lightning is that—generally—the occurrence and immediate danger of lightning is over after thirty minutes have passed since its last strike.

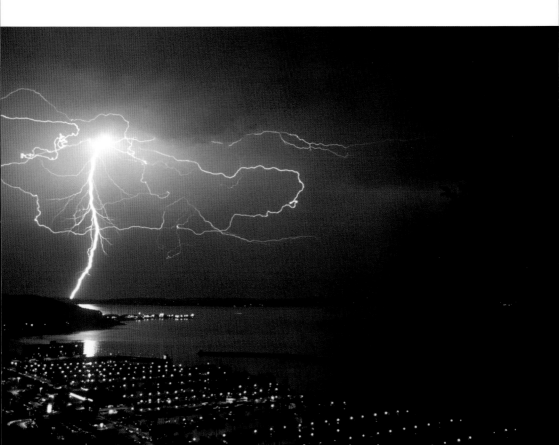

Glorious Incandescence

Polar Auroras and Airglow

Nitrogen and oxygen in the upper atmosphere glow purple and green on the evening of July 24, 2004, at Little Wall Lake in central Iowa. The photographer was alerted to the possibility of an auroral display via an alert sent to his cell phone from www.spacew.com.

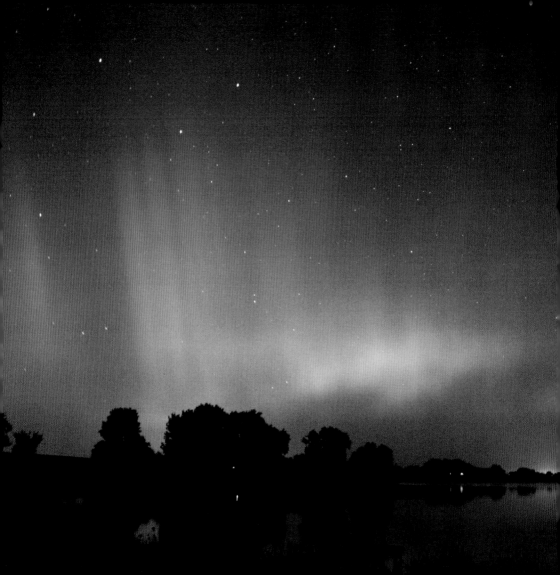

From vaunted prominence at the top of the world comes another source of glorious and peerless magnificence. The polar aurora dances in swashbuckling incandescence, as shimmering transients of excited gases burst into sky-high fireworks and shower the nighttime with vitalized red, green, and purple exhilarations. Twisting and undulating wisps, bands, streaks, and curtains release electrical energy and a spirited spectacle over our heads.

The mantle of gently undulating fluorescence nightly drapes the Earth's poles, belying its furious extraterrestrial origins in the Sun's thermonuclear furnace and its subsequent violence with the planetary magnetic fields. To understand more of how this works, our story must begin there.

The gravitational pressure at the center of the Sun is so great that hydrogen atoms are fused together to create helium. The tremendous amount of energy released in this process is radiation flung into space as the various forms of electromagnetic waves (of which we spoke in the first chapter). The intense force of all this radiation rips other hydrogen atoms into separate shreds of freely floating electrons and protons, called plasma. Some of the plasma flows along magnetic lines from the surface up into the Sun's atmosphere and back to the nuclear inferno, in great loops that are bigger than the diameter of the Earth.

As the radiation surges away from the Sun at the speed of light, it also tears away some of the plasma in its torrent, as well as some of the Sun's magnetic field. This flow of plasma and magnetic force in combination with the radiation is called solar wind. Solar wind is actually quite dilute, with a density of only a few particles per cubic inch. It lumbers along in space at just 200 to 600 miles per second.

Meanwhile, back on Earth, our home planet also possesses a magnetic field that flows in great loops around and through it. Called the magnetosphere, this field would be as symmetric as that around a common bar magnet if there were no solar wind. But because it is constantly bombarded by free-flowing electrons, protons, and the magnetic force, it is compressed on its Sun side and stretched out on its night side by the electromagnetic charges. The constantly fluctuating amounts and intensities of the solar wind keep the magnetosphere vacillating, in continual flux and turmoil, which in turn controls the highly animated displays we see.

Most of the solar-wind particles simply deflect around the Earth from 40,000 miles away, following the magnetic-field lines of the magnetosphere, and continue on into space. But there are two "cusps" in the field that are aligned nearly perpendicular to the Earth at the north and south magnetic poles. The portions of solar wind that flow along these lines enter the Earth's atmosphere and are responsible for the colorful auroral splendors.

As the solar wind particles strike the molecules of the upper air, they impart some of their energy to those atoms and molecules of nitrogen and oxygen, temporarily exciting them to a higher energy level. As the molecules return to their former state, they release the newly acquired energy as photons (particles of light) and more electrons, which in turn zap other molecules into releasing more photons. The combined release of all these photons causes the glow we call aurora.

Because nitrogen and oxygen each release photons at particular wavelengths and altitudes, we see

Plasma (free electrons and protons) conducts electricity, which is what is used to illuminate the gases in fluorescent and neon lights. Similarly, beams of electrons create images on television and computer screens as they strike phosphorescent chemicals, coating the screens, which then glow in different colors.

varying shades of red, green, and purple at varying heights. Although an auroral episode may comprise thousands of colors (which are more easily detected by photographic film than our eyes), only a few are dominant. The brightest and most common auroral light is greenish-white, emitted by atomic oxygen (O) around sixty miles above the ground; higher, above ninety-five miles, single oxygen atoms produce a diffuse red glow. Pinkish light on the undersides of arcs and bands comes from atomic nitrogen (N) as low as forty miles, while molecular nitrogen (N_2) emits bluish purple light at the highest levels. The mixture of the major green, red, and purple emissions may at times combine to give the aurora an overall shiny, whitish glow.

EARTH'S MAGNETOSPHERE

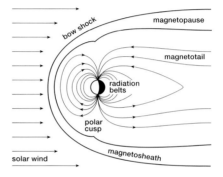

As observed from higher latitudes, the aurora at its fullest flourishes resembles shifting, softly pleated draperies of multiple sheets, as the discharged photons descend toward the upper atmosphere. From space, the Northern Hemisphere's aurora borealis, or northern lights, appear as a ring of light surrounding the magnetic north pole, near the northwestern tip of Greenland.

Meanwhile, back on the Sun, variations in the intensely magnetic sunspots (with irregular eleven-year cycles), mass ejections of plasma, solar flares, and other deviations in solar-energy levels greatly affect the intensity of the solar wind, which in turn affects the intensity and extent of the auroral display. When the solar wind is calm, the auroras appear only at high latitudes and may be quite faint. But Sun flares and high numbers of sunspots can greatly increase the disturbances in the magnetic field below an aurora and precipitate an explosive breakout called a substorm.

Substorms are dramatic displays in which the aurora slowly expands, then suddenly brightens, starting with a small spot. That spot rapidly grows to fill the entire oval and, from an observer's viewpoint, may pervade the whole sky in under a minute with rapidly moving, spiraling curtains of shimmering reds,

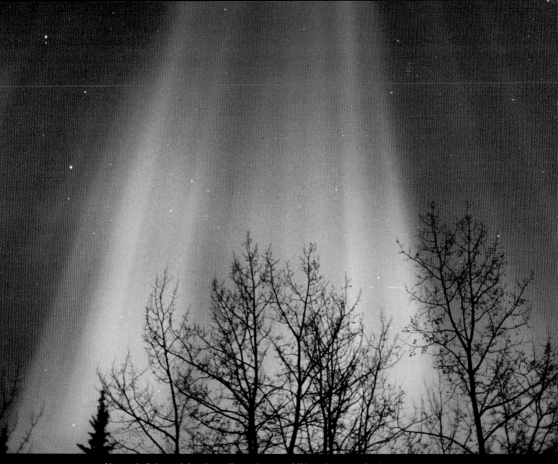

Heavenly light exclaims its radiance in ever-shifting showers of splendor.

Narrow rays or streaks often signify the start of dramatic displays called auroral substorms. The great red rays visible the night of March 30, 2001, displayed a hue rarely seen in Alaskan skies, produced by ionization of high-altitude atomic oxygen.

Auroral rays appearing to radiate away from a point are referred to as a corona. The spectacular 1999–2000 auroral-observing season for central Alaska—coinciding with the solar-maximum eleven-year sunspot cycle—climaxed on April 6, 2000, with the largest magnetic storm to hit the Earth in eleven years which was witnessed as far south as Georgia in the United States, throughout Europe, and even in South Africa. Even though the storm ended within an hour after arriving in Alaska, Jan Curtis was successful in capturing this full, multicolored corona directly overhead in a ten-second exposure.

209

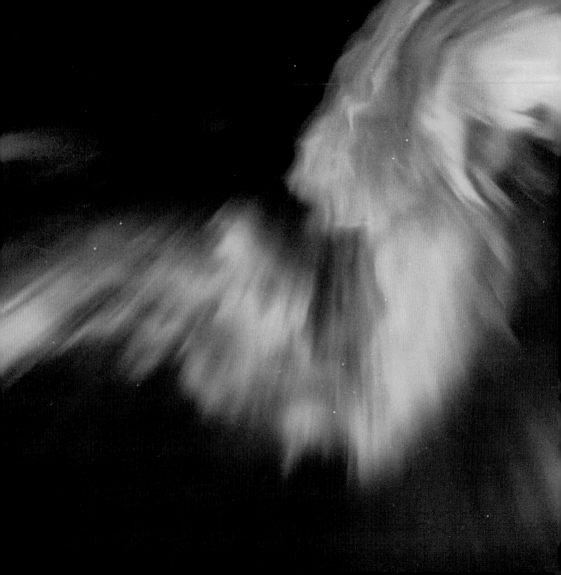

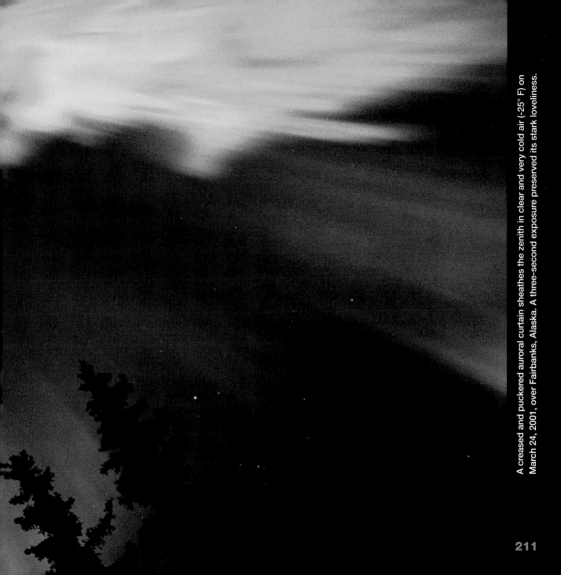

A creased and puckered auroral curtain sheathes the zenith in clear and very cold air (-25° F) on March 24, 2001, over Fairbanks, Alaska. A three-second exposure preserved its stark loveliness.

LOCATING AURORAS The width of the auroral band ranges from 6 to 600 miles. It is dependent on the level of solar activity, and is in constant existence and flux, although sunlight drowns out its visibility during the day.

The best locations from which to see the aurora are near the oval band. In the northern hemisphere that includes Alaska, northern and central Canada, the southern tip of Greenland, Iceland, and the northern coasts of Norway and Siberia. In the southern hemisphere, the oval mainly encompasses Antarctica, although the periphery includes the island of Tasmania and the southern tip of New Zealand.

Spitzbergen (also known as Svalbard) in the confluence of the Arctic Ocean and the Greenland, Barents, and Norwegian Seas (78° N, 20° E) is one of the ideal locations. For a ten-week period around the winter solstice, it is dark enough, even during the day, to watch the aurora that appears directly overhead at noon.

Auroras in the northern and southern hemispheres are near mirror images of each other, with subtle differences owing to the varying conditions of space weather. Known as aurora borealis in the northern hemisphere and aurora australis in the southern hemisphere, they are occasionally visible from middle latitudes.

AURORA OVAL FROM SPACE The global distribution of auroral fluorescence is a 2,500-mile-wide oval band centered on both magnetic poles, shown here as the aurora australis (southern lights) over Antarctica on September 11, 2005—four days after a record-setting solar flare sent huge bursts of plasma earthward. As the level of disturbance of the magnetosphere by the solar wind increases, the oval expands equatorward.

greens, and purples. The display may last thirty to ninety minutes before subsiding with diffuse glowing patches blinking on and off. About 1,500 of these substorms occur each year, with up to several per night during the periods of highest solar activity.

The typical nightly production begins with an overture of a faint glow at the poleward horizon. Act I opens with a single long arc oriented east to west. It usually boasts a well-defined base and may develop curls and waves and brighten considerably. The curtain rises as the next act introduces vertical rays or streaks that extend and combine into bands of broadly folded, shimmering, and shifting draperies of greens, reds, and violets, moving rapidly from horizon to horizon. Now at its dramatic climax, the late show's premiere may last just a few minutes or up to several hours. As dawn approaches, the final act showcases a subdued veil overspreading a large part of the sky, which exits quietly in fading or pulsating patches. At any time, one or all of the highlights may be reprised for further fanfare and extended curtain calls.

OBSERVING AURORAS

The sky must be clear and dark. The naked eye is the best equipment—since binoculars and telescopes cannot improve the view of such nebulous structures.

At high latitudes, the aurora is visible nearly every night, at least faintly even when the solar wind is calm. But since summer nights do not get dark, the best times are during the winter, when the weather also tends to be clear and cold. Keep in mind that standing around in cold darkness requires dressing much more warmly than you would when going skiing!

Because of the geometric relationship between the Earth and Sun, displays that can be seen from midlatitudes and lower latitudes are more likely to occur during the months of March and April and September and October when nights and days are roughly equal in length. Plan to search the skies between 11 P.M. and 2 A.M. as the most active and brilliant displays usually occur around midnight.

AIRGLOW

Separate from the lustrous light sources of polar auroras, starlight, and *gegenschein,* the nighttime sky has a luminescence all its own, called—simply—airglow. On even the darkest nights, it allows us to distinguish the silhouette of an object held against the dark sky.

Like aurora, airglow is due to photons emitted in the upper atmosphere from energized states, but unlike aurora, it is a globally distributed, featureless luminosity whose energy source is solar radiation, not the solar wind. Several kinds of processes, which involve various interactions between oxygen, nitrogen, and sodium, contribute to the overall emissions. Airglow is brightest in a narrow layer about sixty miles high.

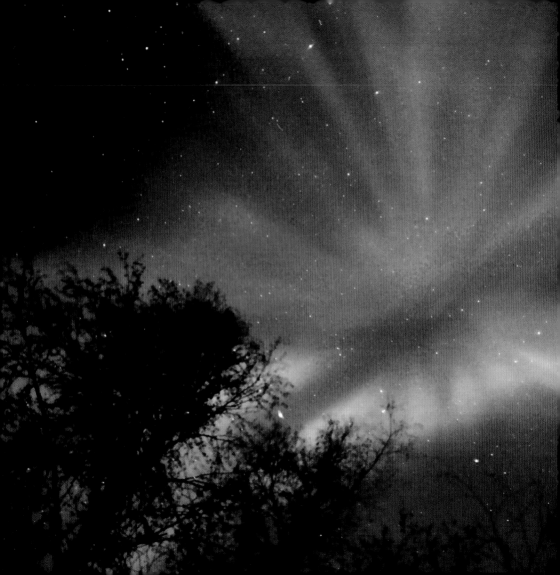

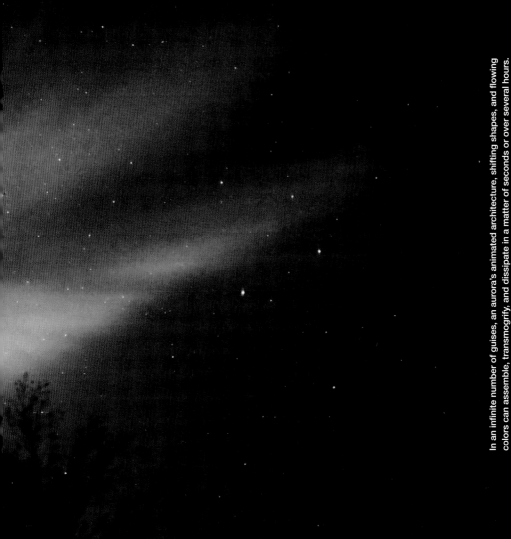

In an infinite number of guises, an aurora's animated architecture, shifting shapes, and flowing colors can assemble, transmogrify, and dissipate in a matter of seconds or over several hours. A rare multicolored full corona bursts over Fairbanks, Alaska, on November 7, 1998, and is preserved for posterity in a three-second exposure.

GLOW A faint glow near the horizon is usually the first indication of an appearing aurora.

Atomic oxygen excites green as the northern lights show begins September 2, 2002, as viewed from Tampere, Finland.

ARC A long bow-shaped arc stretches east to west along the horizon. It usually has a well-defined base, which may develop curls or waves.

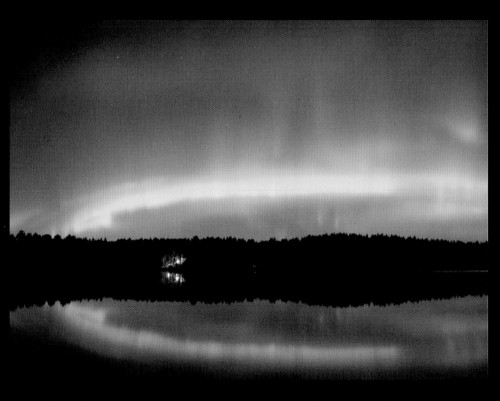

Lake Särkijärvi in Finland (61° N) reflects the artistry of an auroral arc, August 20, 2006.

RAYS Narrow vertical rays or streaks often signify the start of a substorm and may combine into bands. Rays appearing to radiate away from a point, due to the observer's perspective, are referred to as a corona.

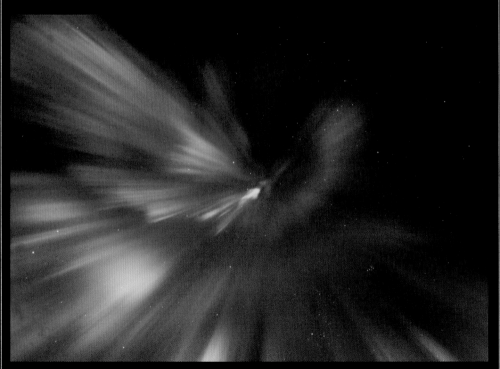

Like paint swirling on a rotating canvas, a full corona appears to radiate away from a point, but the pattern is the result of our individual perspectives as the rays follow parallel paths to the magnetic zenith.

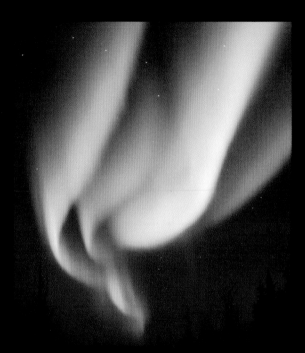

BANDS Broad folded curtains form and move in undulating waves and curves during peak intensity.

Ribbon candy drapes the Alaskan sky on October 4, 2000, at about 9:30 P.M. and sweetens the scene shared with the Big Dipper. The portion near the horizon is actually sixty miles above the Earth and some 300 miles to the north. A twelve-second exposure caught the stunningly beautiful multifolded curtain.

VEIL A diffuse faint glow across a large part of the sky often precedes the end of the display.

A south-southeast view from Langhus, Norway, reveals the mellowing reds of atomic oxygen and nitrogen veiling the sky very early on the morning of October 22, 2001.

PATCH An indistinct tinted nebulous area pulsates in intensity.

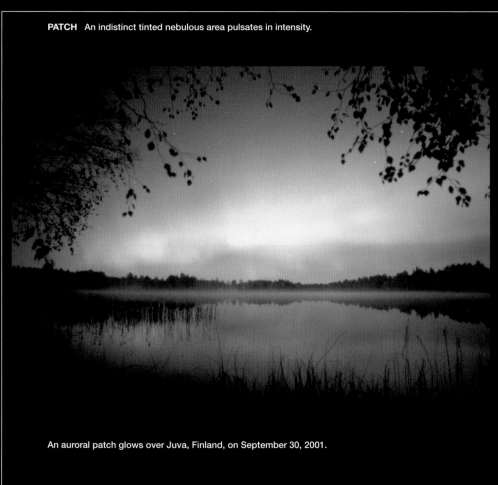

An auroral patch glows over Juva, Finland, on September 30, 2001.

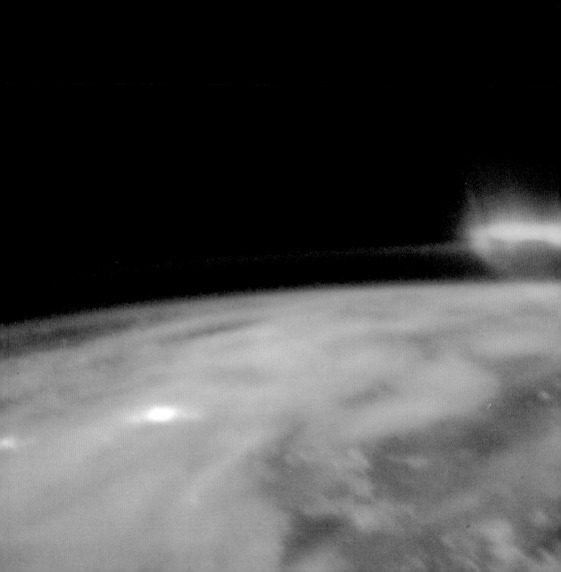

AIRGLOW AND MORE This unique view from space captures several phenomena in one grand expanse. The pale-green band above the horizon is airglow, emitted as molecules broken apart by solar radiation recombine. It is always present throughout the atmosphere, but is so faint that it can only be seen at night by looking "edge on" from a vantage point in space. A green and red aurora dances atop the airglow. Below, bright spots in the clouds reveal electrical discharges much closer to the ground in severe thunderstorms.

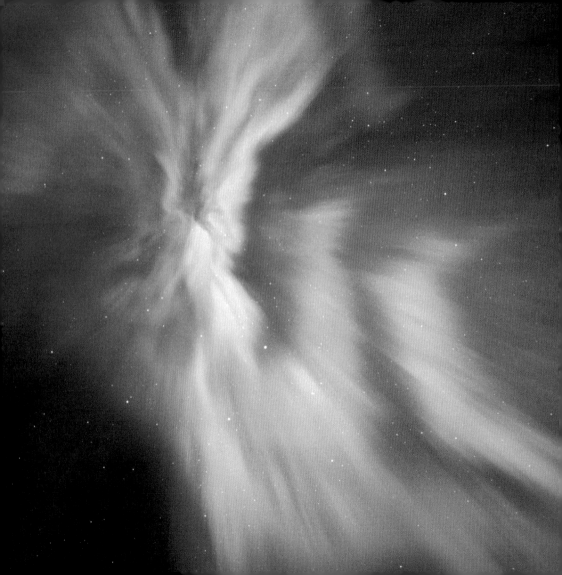

↑ A great luminous curtain swirls green and gorgeous over Wood Buffalo National Park in Northwest Territories in Canada, very early on September 5, 2003. The night was so dark when the display began that the photographer needed a large flashlight to set up his equipment, but the auroral eddy grew in intensity until it illuminated the entire forest around him. Mike Grandmaison preserved its portrait with a thirty-second exposure.

← A sky tie-dyed with excited oxygen and nitrogen bursts over southwestern Finland on October 23, 2001.

PREDICTING AURORAS

Since aurora displays are more widespread and intense when the solar wind is greater, noting when large ejections from the Sun are hurled in our direction gives two to three days' notice. Because the Sun rotates on its axis once every twenty-seven days, an active region that produced a good display may cause another twenty-seven days later. Disturbances in radio, cellular phones, and satellite TV transmissions are also an indication of more intense solar activity.

The shortwave radio station WWV, transmitting continuously on 5, 10, and 15 MHz from Fort Collins, Colorado, broadcasts a solar geophysical forecast regularly every hour.

The Web site of the Space Environment Center of the U.S. National Oceanic and Atmospheric Administration reports on current geomagnetic conditions and solar wind, and estimates the current position of the auroral oval: www.sec.noaa.gov/SWN/index.html.

INTERPRETING AURORAS

What do the displays mean? Auroral events reveal conditions in the Earth's upper atmosphere (the so-called space weather) that are increasingly relevant to daily technological affairs. Such data, when analyzed by astrophysicists and other scientists, can lead to improved technological methods and safety measures in the communications, energy distribution, and aerospace industries.

ANALYZING
How many sources of light account for this incredibly beautiful and temporal celestial scene over Norway?
See page 229.

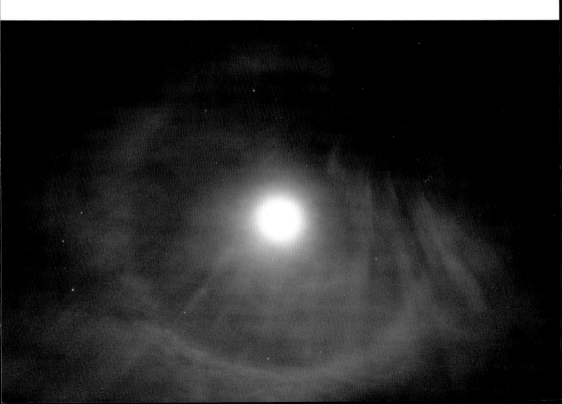

ANSWERS TO ANALYZING QUESTIONS:

p. 38: What trick of light is happening in this series of two photographs taken minutes apart?

No trick of light here—just its absence in a vast triangle in the sky. The shadow of Mount Teide, Tenerife Island (height: 12,188 feet), is cast on altocumulus at 12,900 feet on the morning of November 20, 2004. The shadow's shape does not resemble the mountain's profile, but rather appears triangular due to perspective. As the Sun rises higher and moves toward the south, the shadow narrows and shifts from the right to the left, as seen from the west on La Palma Island in the Canary Islands, off the western coast of Morocco. The shadow loses contrast with its surroundings, and the deep reds fade to pink-orange and yellow, as the sun rises and the sunlight is scattered through a shorter cross section of the atmosphere.

p. 65: What remarkable set of circumstances has glazed this evening sky?

The exhaust from a Minotaur rocket launched from the Vandenberg Air Force Base, California, on April 14, 2006, is differentially spread by the wind at varying heights, while light from the below-horizon Sun diffracts through it, displaying a spectacularly bright iridescence.

p. 107: What combination of natural effects has caused this unique apparition?

A perfect alignment of the Earth, Sun, and Moon orchestrates a total solar eclipse on March 29, 2006. As Belek, Turkey, passes into the center of the Moon's umbral shadow, the Sun's outer atmosphere (called the corona) becomes visible in a white outline around the Moon. Just enough sunlight edges along the line of sight at nine seconds before totality to spray a double corona in the Earth's atmosphere by diffracting through a mist of Turkish pine pollen. The size of the pollen grains was calculated to be about 90 microns based on the sizes of the coronas and the Sun's disk. A small camera lens flare accounts for the green smudge at the ten o'clock position.

p. 141: What can you decipher from this cryptic skywritten script? What wrote it?

Columnar crystals and diamond dust of extraordinary quality following a very early morning snowfall drew a stunning display of the parhelic circle (the horizontal white arc), supralateral arc (the vertical colored arc in the upper right), infralateral arc (the colored arc on the right below the parhelic circle), and the 22° halo (left) with a particularly bright parhelion. Extending downward from the top center is a faint upper tangent arc. Barbara Landl read the storied sky at 11:20 A.M. on December 20, 2005, from the Swiss Federal Institute for Snow and Avalanche Research in Davos (the same event as the upper tangent arcs and company photo on page 109) and recorded it with a simple point-and-shoot digital camera.

p. 175: What story can you tell from this series of images?

The photographer reports: "On a fresh February morning, I took these pictures of Saint Nicolas Island, in

the Glénan Archipelago, on the Kermil beach, profiting from its relief. The air was cold, at 30° F, overlying the warmer sea, at 52° F. The topmost picture had been taken down on the beach near the sea, at about five feet high, and the bottom one at about sixty-five feet of elevation.

"Near the shore, only the higher structures of Sheep's Island appear in towering images: Lighthouse, stakes, and summits are taller than they are in reality. As I climb the beach, these structures shrink and the island seems to float above the sea, with the sky and its upper portions mirrored below. At sixty-five feet high, the view sharpens and most of the inferior mirage disappears: At last Saint Nicolas is touching the sea." Laurent Lavader photographed the series off the coast of Brittany, France, on February 28, 2005, in the Glénan Archipelago's white sandy beaches and shallow sea.

p. 203: What can you deduce about the nature of this erratic sky-scribbling over Seattle?

In a rare appearance over Seattle, Washington, lightning showcases its spontaneous versatility. Cloud-to-cloud streamers snake about in a jagged jig overhead while cloud-to-ground dart leaders and ground-to-cloud return strokes share a transit channel, flashing the night with their charged presence. Their combined brilliance is instantaneously reflected as glimmer in Puget Sound. Above, an indication of the lengths to which the sky streamers are going is found in their varying shades of white to red to orange as more of the shorter wavelengths are scattered with increasing distance.

p. 227: How many sources of light account for this incredibly beautiful and temporal celestial scene over Norway?

The Moon, near apogee at a distance of over 250,000 miles, shines by reflected sunlight and appears hazily through a thin veil of cirrus clouds at about 25,000 feet, whose ice crystals redirect some of the light to create a 22° halo.

Between 60 and 600 miles high, molecular nitrogen and atomic oxygen glow purple and green in the solar wind encountering the magnetosphere.

To the lower left of the Moon, Saturn receives light from the Sun some 900 million miles away and reflects it to our eyes another 821 million miles away.

Above Saturn are the twin stars of Gemini, shining by their own nuclear radiation. Pollux, the lower one, reveals itself as a yellow-orange giant star thirty-four light years away. Castor is a hot white sextuple star system, twinkling some fifty light years distant.

To the right of the Moon, near the halo's edge, gleams the open star cluster Pleiades in the constellation of Taurus. Containing about 500 stars, most of which are young, hot blue stars, its storied light arrives from a distance of about 135 parsecs, taking about 440 years to reach our eyes during this brief celestial display over Langhus, Norway, on January 21, 2005.

Glossary

ABSORPTION. The process in which radiation is retained by a substance as heat energy.

AFTERGLOW. The collective term applied to purple light, twilight glow, and the other colors of the western twilight.

AIRGLOW. Featureless nighttime luminescence in the upper atmosphere caused by photon emissions from oxygen and nitrogen molecules whose source is solar radiation; distinct from the solar wind that produces auroras.

ALEXANDER'S DARK BAND. The dark-colored band between the primary and secondary rainbows.

ALPENGLOW. The reappearance of sunset colors on a mountain summit; also, a similar phenomenon preceding the regular coloration at sunrise.

AMPERE. A unit of measure of the flow of electric current.

ANGULAR MEASURE. The measure of the apparent diameter of a celestial object or the distance between objects; expressed as an angle in degrees.

ANTHELIC POINT. The point on the celestial sphere 180° opposite the Sun at the same altitude.

ANTHELION. A luminous white spot produced by ice crystal reflection appearing on the parhelic circle 180° from the Sun; also called the countersun.

ANTICORONA. A diffraction phenomenon similar to the corona, but occurring at the antisolar point, where the head of the observer would be positioned; also called a glory.

ANTICREPUSCULAR RAYS. Crepuscular rays that appear to converge at the antisolar point.

ANTISELENE. The luminous white spot produced by ice crystal reflection appearing on the paraselenic circle 180° from the Moon.

ANTISOLAR POINT. The point on the celestial sphere directly opposite the Sun, on a line from the Sun through the observer.

APPARENT MAGNITUDE. The measure of the brightness of celestial objects. Apparent Magnitude 1 is 100 times brighter than Apparent Magnitude 6; each whole number is 2.512 times brighter than the next; Apparent Magnitudes brighter than 0 are minus figures.

ATMOSPHERE. The sphere of air surrounding the Earth; 99.9 percent of its mass is within twenty-nine miles of the surface.

AUREOLE. A poorly developed corona, characterized by a bluish-white disk around the Sun or Moon with a reddish brown outer edge.

AURORA. A sporadic electrical discharge in the upper atmosphere appearing as glowing lights in the nighttime sky; aurora borealis occurs in the Northern Hemisphere; aurora australis occurs in the Southern Hemisphere.

BALL LIGHTNING. A rare, luminous ball of light 1–3 feet in diameter that may move rapidly among or through objects, or float in the air, before exploding or dissipating.

BISHOP'S RING. A faint, broad, reddish brown corona formed by diffraction of light in dust clouds, especially those from volcanic eruptions.

BLUE JETS. Electrical discharges ejected in narrow cones from the top of the most electrically active core of a thunderstorm.

BLUE STARTERS. Bright, short, blue jets that discharge over the large hailstone regions within a thunderstorm.

BRIGHT GLOW. A whitish or yellowish luminance of about a 10° radius centered on the Sun during twilight.

BRIGHT REFLECTION. A widespread diffuse reflection of the Sun above the countertwilight arch during sunrise and sunset.

BROCKEN BOW. A glory that appears on the head of an observer's shadow.

BROCKEN SPECTRE. The illusory appearance of a gigantic figure observed on a cloud or fogbank from a higher altitude in which a Brocken bow forms about the antisolar point.

CELESTIAL SPHERE. The apparent sphere of infinite radius, having Earth as its center, upon which all heavenly bodies and many optical phenomena appear; used as a sky map to identify directions, locations, and points of light sources.

CIRCUMHORIZONTAL ARC. A halo phenomenon consisting of a colored arc extending about 90° parallel to the horizon and about 46° below the Sun.

CIRCUMSCRIBED HALO. A metamorphic form of the upper- and lower-tangent arcs of the 22° halo, and for solar elevations above 30°, as they merge into a kidney-shaped luminous curve circumscribed about the 22° halo.

CIRCUMZENITHAL ARC. A brightly colored arc about 90° in arc-length, centered on the zenith, about 46° above the Sun.

CLOUDBOW. A pale, diffuse arc, similar to a rainbow, formed in cloud droplets; also called a white rainbow.

CONSTRUCTIVE INTERFERENCE. The combined effect of the crests or troughs of two or more waves reaching the same point simultaneously.

CONTRAIL. The condensation trail of an aircraft; a cloudlike streamer that forms behind flying aircraft in cold, humid air.

CORONA. 1: A concentric series of prismatic colored rings centered on the Sun or Moon, caused by light diffracting through the tiny water droplets of a thin cloud; 2: auroral rays that appear to radiate away from a point; 3: the outermost region of the Sun's atmosphere.

CORONA DISCHARGE. A luminous and often audible discharge of static electricity from pointed objects into the atmosphere; also called St. Elmo's Fire.

COUNTERTWILIGHT ARCH. The pink or purplish band of light appearing above the antisolar point during twilight, rising with the antisolar point at sunset, and setting with it at sunrise; also called the antitwilight arch or the Belt of Venus.

CREPUSCULAR RAYS. Alternating light and dark bands of rays and shadows that appear to diverge in a fanlike array from the Sun's position; caused by clouds intercepting the sunlight.

DART LEADER. A flash of light that propagates down the same channel in which the first flash (return stroke) occurred in a lightning strike. Once the flash of light reaches the ground, it causes another return stroke upward. The dart leader is distinguished from a stepped leader in that it does not branch off from the original channel.

DESTRUCTIVE INTERFERENCE. The cancelled effect of the crest of one wave and the trough of another wave reaching the same point simultaneously.

DIAMOND DUST. Minute ice crystals suspended in the air near the ground in very cold weather.

DIFFRACTION. The bending of light as it passes through an object approximately the same size or greater than the wavelength of light, resulting in dispersion into its component colors.

DISPERSION. The separation of visible light into its component colors by refraction or diffraction.

DUCTING. A type of superior mirage in which the bending of light rays within a thermal inversion is stronger than the curvature of the Earth, and rays traveling inside it can be continuously guided along the surface—as if in a duct—without ever escaping to space.

EARTH SHADOW. During twilight, a curved bluish-gray band that rises or sinks toward the horizon opposite the Sun.

ECLIPTIC. The apparent path of the Sun around the Earth in the celestial sphere.

ELECTROMAGNETIC WAVES. Energy propagated as waves advancing disturbances in electric and magnetic fields existing in space or other media.

ELVES. Huge disk-shaped regions of electrical luminosity that expand up to 300 miles across and vanish in less than one millisecond over thunderstorms; an acronym for Emission of Light and Very low frequency perturbations due to Electromagnetic pulse Sources.

FATA BROMOSA. A superior mirage of the polar regions appearing as a featureless fogbank.

FATA MORGANA. A complex mirage of multiple gross distortions consisting of both inferior and superior mirages resulting from refraction of light through vertically adjacent layers of varying density gradients. A strong temperature inversion over a relatively warm sea is the usual cause.

FOGBOW. A pale, diffuse arc—similar to a rainbow—which is formed in fog droplets; also called a cloudbow or a white rainbow.

GEGENSCHEIN. An oval patch of faint luminosity at a point along the zodiacal light opposite the Sun; also called counterglow.

GLORY. A diffraction phenomenon similar to a corona, but occurring at the antisolar point, where the head of the observer would be position; also called an anticorona.

GREEN FLASH. A brief, brilliant green glow of the upper edge of the rising or setting Sun. Several kinds have been identified, with distinctive characteristics and suspected causes.

HALO. The generic term for a wide variety of luminous rings or arcs produced as light from the Sun or Moon refracts and reflects through ice crystals in the air.

HEILIGENSCHEIN. A diffuse, white luminous ring occasionally seen about the head of an observer's shadow; formed by refraction, reflection, and diffraction of light from a low Sun shining on a surface containing spherical water droplets.

HORIZON. The distant line along which the Earth and sky appear to meet.

ICE CRYSTALS. Any one of a number of water-crystalline forms including hexagonal plates, columns, needles, dendrites, and combinations.

ICE PRISMS. Very small, un-branched ice crystals; also known as diamond dust.

INFERIOR MIRAGE. An image of an object formed below its true position by refraction along the line of sight; the most common type of mirage.

INFRALATERAL TANGENT ARCS. A rare pair of oblique arcs which form below and convex to the Sun, and tangent to the 46° halo.

INFRARED RADIATION. Electromagnetic radiation with wavelengths between those of visible red light and microwaves; ranges from .75 microns to 1 mm.

INSOLATION. The daily incoming solar radiation.

ION. In atmospheric electricity, any one of several types of electrically charged submicroscopic particles normally found in the atmosphere.

IONOSPHERE. The portion of the Earth's atmosphere defined by its composition, unlike the other named portions, which are defined by their temperature structures. It consists of free electrons and ions that affect the propagation of radio waves, and extends from about thirty-five miles to about 620 miles above the Earth.

INVERSION. See thermal inversion.

IRIDESCENCE. The pastel coloration caused by diffraction of light through and exhibited by clouds of very small, uniformly sized droplets or ice crystals. It may be observed as parallel bands of color along the cloud's outline, or as a colored segment of a large corona.

IRIDIUM FLARE. A dramatic, nonnatural nighttime glint of reflected sunlight off an Iridium communications satellite.

LATE MIRAGE. A mock mirage in which, if one looks upward through a thermal inversion, an image of the Sun reappears below the inversion, after the Sun has "set" above it.

LATERAL MIRAGE. An image of an object displaced to one side of its true position by refraction along the line of sight; also called a mural mirage.

LENTICULARIS. A lens-shaped cloud; often it displays iridescence.

LIGHTNING. A luminous electric discharge observed as a thin, branching channel of light; a short circuit between two locations. Temperatures in a lightning discharge can approach 50,000°F, the highest naturally occurring temperature on Earth.

LOOMING. A refraction phenomenon in which an image is displaced upward, permitting objects that are below the horizon to be seen.

LOWITZ ARC. A rare optical phenomenon in which a luminous arc extends obliquely downward from the 22° parhelia, concave toward the Sun.

LUMINOUS LEADER. A streamer that initiates the first phase of each stroke of a lightning discharge.

LUNAR ECLIPSE. The event of the Moon passing through the Earth's shadow.

MAGNETOSPHERE. The magnetic field that flows around and through the Earth, controlling the plasma within it and protecting us from solar radiation. Its size and shape is influenced by the solar wind which is compressed into a bow shock sunward and extended into a large tail downwind. Interactions of the solar wind and the magnetosphere produce auroral displays in the upper atmosphere.

MIRAGE. A refraction phenomenon in which the image of an object is displaced from its true position. Simple mirages may be inferior, superior, or lateral, in which the image is displaced below, above, or to one side of the object's true position.

MOCK MIRAGE. A complex mirage that produces inverted images of the Sun and Moon near the horizon when the observer looks downward through a thermal inversion.

MOCK MOON. *See paraselena.*

MOCK SUN. *See parhelia.*

MOONBOW. A rainbow formed by light from the Moon; colors in a moonbow are usually difficult to detect.

NACREOUS CLOUD. An iridescent cloud of the stratosphere, occurring about six-to-eighteen miles above the Earth and resembling cirrus or altocumulus lenticularis.

NADIR. The point on the celestial sphere directly below the observer; -90° from the horizon.

NANOMETER (NM). One thousand millionth of one meter in length; the common unit used to express light wavelengths.

NOCTILUCENT CLOUD. A cloud similar in appearance to cirrus, that forms in one of the ionized layers of the atmosphere at about fifty miles above the Earth's surface. It has recently been renamed a Polar Mesospheric Cloud.

NOVAYA ZEMLYA MIRAGE. A ducting mirage that displaces an image of the Sun over the southern horizon weeks ahead of the Sun's scheduled arrival in polar regions.

OBLATENESS. The apparent flattening of the Sun or Moon near the horizon due to atmospheric refraction.

PARANTHELIA. Refraction phenomena similar to the parhelia, but generally occurring at angular distances of 120°, and occasionally at 90° and 140°, from the Sun on the parhelic circle.

PARANTISELENA. A refraction phenomenon in moonlight corresponding to paranthelion in sunlight.

PARASELENA. A weakly colored lunar halo phenomenon identical in form to the solar parhelia; also known as a mock moon.

PARASELENIC CIRCLE. A luminous horizontal circle passing through the Moon, produced by reflection of moonlight from ice crystals; corresponds to the parhelic circle through the Sun.

PARHELIA. Two luminous spots that appear at points about 22° on both sides of the Sun, and at the same elevation as the Sun; formed by refraction in hexagonal ice crystals; also called mock suns or sun dogs.

PARHELIC CIRCLE. A luminous horizontal circle passing through the Sun, produced by reflection of sunlight from ice crystals.

PARRY ARCS. A class of faintly colored arcs appearing above and below the Sun; produced by refraction and internal reflections through horizontally oriented ice crystals falling with two faces vertical and two faces horizontal.

PENUMBRA. The area of partial shadow surrounding the main cone of a shadow cast by an object in sunlight.

PHOTON. A discrete particle of solar radiation having no mass or electrical charge, but having an indefinitely long lifetime.

PLASMA. An electrically conductive gas of freely flowing electrons and protons.

POLARIZED LIGHT. Light that vibrates in only one plane.

PURPLE LIGHT. The luminous purple glow observed on a clear day over a large region of the western sky after sunset and over a large region of the eastern sky before sunrise.

RADIATION. The process by which electromagnetic energy propagates by wave motion through free space.

RAINBOW. Any one of a family of circular arcs consisting of concentric colored bands centered on the antisolar point. Rainbows are formed by sunlight or moonlight refracting and reflecting through individual raindrops falling in a sheet. The primary rainbow of about a 42° radius is the brightest bow, exhibiting red on the top. The secondary bow of about 51° displays the reverse spectral order. Supernumerary bows are formed by the additional process of diffraction through the drops and appear just inside the primary bow.

RED SPRITES. Large flashes that appear directly over an active but decaying thunderstorm coincident with cloud-to-ground flashes.

REFLECTION. The bending back of light when it strikes a surface. Specular reflection occurs at a uniform angle when the reflecting surface is smooth and polished; diffuse reflection occurs at many angles when the reflecting surface is rough.

REFLECTION RAINBOW. A rainbow formed by sunlight that reflects upward from calm water behind the observer.

REFRACTION. The bending of light passing from one medium to another of differing density.

RETURN STROKE. The intense luminous streamer that propagates upward from the Earth to the cloud base in the last phase of each lightning stroke of a cloud-to-ground discharge.

ST. ELMO'S FIRE. A luminous and often audible discharge of static electricity from pointed objects into the atmosphere; also called a corona discharge.

SCATTERING. The deflection of light by particles smaller than the wavelength of light, selective scattering, also known as Rayleigh scattering, varies with the wavelength; nonselective scattering deflects all wavelengths uniformly.

SCINTILLATION. The rapid variation in apparent position, brightness, or color of a distant object viewed through the atmosphere. Astronomical scintillation is the effect observed on the planets and stars; terrestrial scintillation, also known as shimmer, refers to the effect on objects within the atmosphere.

SHIMMER. Terrestrial scintillation.

SINKING. A refraction phenomenon in which an image is displaced downward, prohibiting objects on or slightly above the horizon to be seen.

SOLAR DEPRESSION. The angular distance of the Sun below the horizon.

SOLAR ELEVATION. The angular distance of the Sun above the horizon.

SOLAR POINT. The momentary point on the celestial sphere at which the Sun is found.

SOLAR WIND. A stream of charged particles (mostly protons, electrons, and ions of many elements) emanating from the Sun at speeds of 185–620 miles per second. Interactions of the solar wind and the magnetosphere produce aurora displays in the upper atmosphere.

SPRITE HALOS. ELVES-shaped electrical glows that precede red sprites and flash downward from the top of a thunderstorm.

STEPPED LEADER. The initial streamer of a lightning discharge; it advances in increments of about 150 feet at a time, pausing about fifty microseconds between advances.

STOOPING. A refraction phenomenon in which a displaced image is vertically shortened.

SUBPARHELIC CIRCLE. A luminous horizontal circle occurring as far below the horizon as the Sun is above it; produced by refraction and reflections of sunlight from horizontal ice crystal columns.

SUBSOLAR POINT. The point on the celestial sphere below the Sun, as far below or above the horizon as the Sun is above or below it.

SUBSUN. A halo phenomenon in which light reflects the Sun off the top surfaces of horizontally oriented ice crystal plates; forms as far below the horizon as the Sun is above it.

SUN CROSS. A halo phenomenon in which bands of white light intersect over the Sun at right angles; a superposition of the parhelic circle and a Sun pillar.

SUN DOG. *See Parhelia*.

SUN PILLAR. A luminous streak of light extending above and below the Sun, the result of reflection from horizontally oriented faces of ice crystals; also called a light pillar.

SUPRALATERAL TANGENT ARCS. A rare pair of oblique arcs which form above and convex to the Sun and tangent to the 46° halo.

SUPERBOLTS. Huge lightning strikes which shoot upward from cloud tops to the upper atmosphere and grow to resemble giant trees or carrots; also called gigantic jets.

SUPERIOR MIRAGE. An image of an object formed above its true position by refraction along the line of sight.

SUPERNUMERARY BOW. *See rainbow*.

TANGENT ARCS. A generic term for a variety of luminous arcs that form tangent to other halo phenomena.

TERRESTRIAL REFRACTION. Any refraction phenomena observed in the light that originates from a source lying within the atmosphere; responsible for the optical phenomena of looming, sinking, stooping, and towering mirages and terrestrial scintillation.

THERMAL INVERSION. An inversion of the normal thermal profile of the atmosphere; when a layer of warmer air lies above cooler air.

THUNDER. The sonic boom created by the rapidly expanding air along the channel of a lightning strike.

TOWERING. A refraction phenomenon in which a displaced image is vertically magnified.

TRANSIENT LUMINOUS EVENTS (TLEs). A poorly understood class of upper-atmospheric electrical discharges that include the imaginatively named red sprites, blue jets, ELVES, and trolls.

TROLLS. Narrow cones of electrical discharge which flash downward from the tendrils of especially vigorous red sprites.

TWILIGHT. The interval of incomplete darkness after sunset and before sunrise. The terms civil twilight, nautical twilight, and astronomical twilight refer to the periods of the Sun's transit below the horizon, with the respective limiting solar depression angles of 6°, 12°, and 18°.

TWILIGHT GLOW. A faintly glowing band of light as the solar depression angle varies between 7° to18°; it is visible over 20°–30° of horizon.

ULTRAVIOLET RADIATION (UV). Electromagnetic radiation with wavelengths between that of visible violet light and X-rays. Most of the potentially hazardous ultraviolet radiation is absorbed by stratospheric ozone.

UMBRA. The dark, central cone of the shadow of an object, cast by the Sun.

UNIVERSAL TIME (UT). The standard against which the world's system of time zones is measured, each one being a number of hours ahead or behind it; also known as Greenwich Mean Time, since it is centered on the prime meridian through Greenwich, England.

VISIBILITY. The maximum distance at which dark objects can be seen and recognized by the unaided eye during the day, or at which unfocused luminous objects of moderate intensities can be seen and recognized by the unaided eye at night.

VOLTAGE. The force of an electrical charge through a conductor.

WHITEOUT. The optical atmospheric condition in which the observer is engulfed in a uniformly white and disorienting glow.

ZENITH. The point on the celestial sphere directly above the observer, 90° from the horizon.

ZODIACAL BANDS. Extensions of faint luminosity extending from the zodiacal light to the *gegenschein*.

ZODIACAL LIGHT. A faint cone of light extending upward from the horizon in the direction of the ecliptic; sometimes seen for a few hours before sunrise or after sunset, it is caused by light scattered from the interplanetary dust cloud.

LIGHT AND COLOR

HUMPHREYS, W. J. *Physics of the Air.* New York: Dover Publications, 1964.

LEE, RAYMOND L., Jr. "Twilight and Daytime Colors of the Clear Sky." *Applied Optics* 33, no. 21 (1994): 4629.

LYNCH, DAVID K., and William Livingston. *Color and Light in Nature,* 2nd ed. New York: Cambridge University Press, 2001.

MEINEL, ADEN AND MARJORIE MEINEL, *Sunsets, Twilights, and Evening Skies.* New York: Cambridge University Press, 1983.

MINNAERT, M. G. J. *Light and Color in the Outdoors.* New York: Springer, 1993.

MURPHY, PAT, AND PAUL DOHERTY. *The Color of Nature.* San Francisco: Chronicle Books, 1996.

NAYLOR, JOHN. *Out of the Blue: A 24-Hour Skywatcher's Guide.* New York: Cambridge University Press, 2002.

RAINBOWS AND HALOS

COWLEY, LES. "Atmospheric Optics". http://www.atoptics. co.uk.

FRASER, ALISTAIR. "Chasing Rainbows: Numerous Supernumeraries are Super." *Weatherwise* 36, no. 8 (December 1983): 280–289.

GREENLER, ROBERT. *Rainbows, Halos & Glories.* New York: Cambridge University Press, 2000.

HALO RESEARCH TEAM. Arbeitskreis Meteore e.V. (AKM). http://www.meteoros.de/indexe.htm.

LEE, RAYMOND L., Jr. and Alistair Fraser. *The Rainbow Bridge: Rainbows in Art, Myth, and Science.* University Park, PA: The Pennsylvania State University Press, 2001.

TAPE, WALTER. *Anarctic Research Series.* Vol. 64, *Atmospheric Halos.* Washington, D.C.: American Geophysical Union, 1994.

———, AND JARMO MOILANEN. *Atmospheric Halos and the Search for Angle x.* Washington, D.C.: American Geophysical Union, 2006.

MIRAGES

FRASER, A. B., AND W. H. MACH. "Mirages." *Scientific American* 234, no. 1 (January 1976): 102–111.

PARVIAINEN, PEKKA. "Mirages in Finland." Virtual Finland. http://virtual.finland.fi/finfo/english/mirage.html.

YOUNG, ANDREW T. "An Introduction to Mirages." San Diego State University Astronomy Department. http://mintaka. sdsu.edu/GF/mirages/mirintro.html.

LIGHTNING

GLOBAL HYDROLOGY AND CLIMATE CENTER. http://thunder.msfc. nasa.gov.

MACGORMAN, DONALD R., and David W. Rust. *The Electrical Nature of Storms.* New York: Oxford University Press, 1998.

NATIONAL SEVERE STORMS LABORATORY, NORMAN, OK. http:// www.nssl.noaa.gov.

RAKOV, V. A. AND M. A. UMAN. *Lightning, Physics and Effects.* New York: Cambridge University Press, 2003.

STENHOFF, MARK. *Ball Lightning: An Unsolved Problem in Atmospheric Science.* New York: Springer, 1999.

WORLD WEATHER INFORMATION SERVICE. http://www. worldweather.org.

AURORA

AKASOFU, S. I. *Secrets of the Aurora Borealis.* Anchorage: Alaska Geographic Society, 2003.

DAVIS, NEIL. *The Aurora Watcher's Handbook.* Fairbanks, AK: University of Alaska Press, 1992.

GEOPHYSICAL INSTITUTE, UNIVERSITY OF ALASKA, FAIRBANKS. http://www.gi.alaska.edu.

SAVAGE, CANDACE C. *Aurora: The Mysterious Northern Lights.* Tonawonda, NY: Firefly Books, 2001.

SOLAR AND HELIOSPHERIC OBSERVATORY, GREENBELT, MD. http://sohowww.nascom.nasa.gov/.

Photo Credits

Abed, Wael, 173
Angel, Heather/Natural Visions, 54–55, 58–59
Arnold, Luc, 162–63
Baker, Hank/Weatherpix Stock Images, 193
Barrett, Bruce, 94 bottom
Bath, Michael, 52–53, 198–99
Becker, Aaron, 67
Borrás, Jose Tous, 138–39
Bruce, Marlene E. (DigitizeThis.com), 153
Cabré, Ramon Baylina, 9, 100
Credner, Till (AlltheSky.com), 62
Crowe, Steve, (www.stevecrowe.co.uk), 82
Curtis, Jan, 208, 209, 210–11, 214–15, 219, jacket back, case front/back, endpaper front/back
Danielsen, Arne/Norway, 2–3, 218, 220, 227
Dubois, Jim, 89
Earth Sciences & Image Analysis Laboratory, NASA Johnson Space Center, 222–23
Edens, Harald (www.weatherscapes.com), 13, 18–19, 49, 50, 122–23, 147 top, 150–51, 187, 188, 194, 195
Ellem, Dave (www.nswstorms.com), 94 top
Faidley, Warren/Weatherstock, 177, 189, 190
Fleet, Richard, 34–35, 77, 87 top, 92, 119
Fox, Jonathan, 134, 135
Grandmaison, Mike (www.grandmaison.mb.ca), 225
HaloSim © L. Cowley and M. Schroeder (www.atoptics.co.uk/atoptics/phenom.htm), 130
Harrington, Bob (Bobqat.com), 46, 47, 69 right, 203
Herd, Carol, author photo
Herd, Daniel, 147 bottom
Herd, Tim, 10, 11, 15, 26, 27, 29, 71, 82,

111 top, 120, 127 bottom, 148 right, 152 bottom, 155 right, 207
Herranen, Emma, 107
Herranen, Henrik and Emma, 216, 217
Hinz, Claudia, on top of Wendelstein/German Alps, 80–81
Hinz, Wolfgang, in Lukla/Himalaya/Nepal, 30
Hlaváčová, Marie, 127 middle
Image Science & Analysis Laboratory, NASA Johnson Space Center, 212
Jupiterimages, 78
Kangas, Lauri, 133, jacket spine
Kilic, Ozan, 84–85
Klee, Jacob A., 136
Koorts, Willie (www.saao.ac.za/~wpk/), 4–5
Kühne, Benjamin/Cologne, Germany 72–73, 87 bottom
Landl, Barbara, 141
Laveder, Laurent (Pixheaven.net), 48, 60–61, 175
Linnansaari, Päivi, 131
Lowe, Vincent, 88, 96
Macmillan Publishers Ltd: *Nature* vol. 423, copyright 2003, 186
Mainka, Ern, 69 left, 74–75, 191
Mayeux, Brian, 182–83
McDonald, Joe, 172
Meniero, Marco (www.meniero.it), 20–21, 31, 44, 57, 148 left, 152 top
Meniero, Marco and Andreina Ricco, (www.meniero.it), 165, 168–69
Miró, Fernando Bullón/Instituto Nacional de Meteorología-Spain, 39
Moilanen, Jarmo, 112–13, 114, 115, 121
Moilanen, Jarmo and Marko Riikonen, 111 bottom
NASA, 12
OAR/ERL/National Severe Storms Laboratory, 201
Parviainen, Pekka, 6, 45, 51, 101, 102–3,

104–5, 125, 143, 154-55, 156–57, 159, 161, 166–67, 170, 224
Peake, Scott/Weatherpix Stock Images, 200
Piikki, Jari, 16, 17, 56, 98–99, 128, 137, 221
Plonka, Brian/The SpokesmanReview/WpN, jacket front
Poulin, Guillaume, 117
Ratkowski, Rob/Maui, 41, 90–91
Richard, Stan (www.nightskyevents.com), 124, 205
Rixen, Christian, 109
Robinson, Dan (StormScenes.com), 185
Scurlock, John/photographer/pilot 22–23
Skorecki, Ryan, 127 top
Spelbrink, Conny/la Palma, 38
Stephens, Jack/Alamy Limited, 144–45
Trzicky, Tomas, 118
West, Steve, 1, 32–33, 65, 79
White, Pete, 97
Woodford, Tony, 24–25
Wurden, Glen/© 1996 IEEE, 180
www.Sky-Fire.TV, 192

I recall my first observation of a halo. My boyhood pal and I were throwing grapes straight up into the air to catch them in our open mouths, when I suddenly and startlingly discovered a "rainbow" in the middle of the sky. I was instantly enthralled, and as the plummeting grape splattered on my glasses, I embarked on a lifelong fascination with light's designs in the sky.

To my teachers, professors, and the countless scientists and researchers who possessed both the understanding and patience to communicate the science behind the beautiful works of airy art, I am truly grateful.

Professional scientists and amateur hobbyists alike from every continent have shared their interests— obsessions?—with me while offering both vital images and insightful interpretations for this project. Not only have I enjoyed working with and learning from my new acquaintances and colleagues around the world, I treasure their friendships. Please note their individual contributions on the previous page; this book wouldn't have been possible without their generous assistance and ample photographic evidence.

The widespread use of digital technology has enabled a greater population than ever to document and share its observations and experiences; this has both advanced atmospheric science and awareness of our wonderful sky—and greatly enabled the reach and development of this book. I invite you to join this fellowship at www.KaleidoscopeSky.net.

The friendly expertise and attentive ways of my editor Charles Kochman in shoehorning the manu-script into place while tempering my overly technical enthusiasms has earned him his own halo. Designer Darilyn Carnes has the master's touch in creating a visual treat with photos, graphics, and text. My agent and book producer, Liz Walker, is a tireless, enthusiastic, and productive professional, whose personal friendship I cherish.

I am most blessed with a wonderful wife and joyful family, who know to come running quickly when I yell, "Look at the sky!" and who have always supported my lofty dreams and ambitions. I love them intensely!

Editor: Charles Kochman
Designer: Darilyn Lowe Carnes
Production Manager: Jules Thomson

Library of Congress Cataloging-in-Publication Data

Herd, Tim.
 Kaleidoscope sky / by Tim Herd.
 p. cm.
 Includes bibliographical references and index.
 ISBN-13: 978-0-8109-9397-6 (hardcover)
 ISBN-10: 0-8109-9397-X (hardcover)
 1. Meteorology—Popular works. 2. Atmosphere—Popular works.
 I. Title.

 QC981.2.H47 2007
 551.56—dc22

 2007016273

Text and compilation copyright © 2007 Tim Herd
Photography credits appear on page 238

Printed and bound in China
10 9 8 7 6 5 4 3 2 1

HNA ▉▊▊▊▊
harry n. abrams, inc.

a subsidiary of La Martinière Groupe

115 West 18th Street
New York, NY 10011
www.hnabooks.com

Pages 4–5: A classic eastern 180° panorama rises in simple elegance and graces the darkening day's end. The appearance of the earth shadow, countertwillight arch and bright reflection signals the start of a clear night's work at the Astronomical Observatory near Sutherland, South Africa on May 30, 2006.

Page 6: Refracting and reflecting through falling ice crystals, sunlight's complex choreography bedazzles the sky with a luminary cast over Turku, Finland. From top to bottom: Arching upward ,a circumzenithal arc; arching downward from the same point, a supralateral arc; the upper portion of the bright disk in the middle is a Parry arc; the lower gull-winged portion is an upper-tangent arc; a 22° hallow with a pair of parhelia on both sides, with a portion of the parhelic circle extending away.

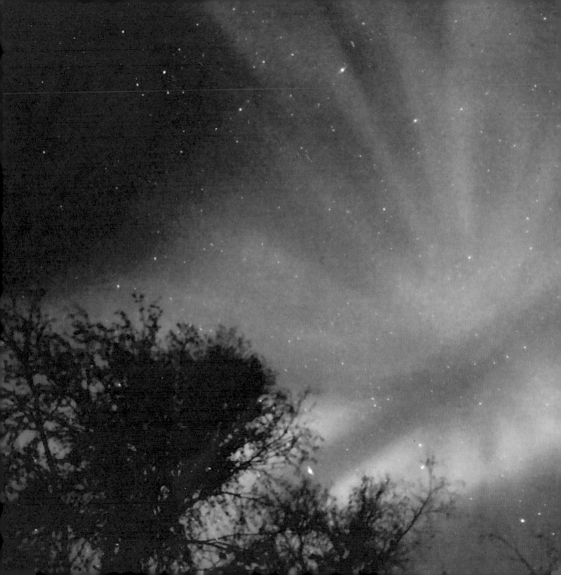